Psycho

Other titles in this series by the same author

London Writing
Occult London
Utopia

Psychogeography

MERLIN COVERLEY

POCKET ESSENTIALS

This edition published in 2010 by Pocket Essentials
P.O.Box 394, Harpenden, Herts, AL5 1XJ
www.pocketessentials.com

A CIP catalogue record for this book is available from the British Library.

ISBN 13: 978-1-84243-347-8

Typeset by Avocet Typeset, Chilton, Aylesbury, Bucks
Printed in Great Britain by Clays Ltd, St Ives plc

To Catherine

Contents

Introduction 9

1: London and the Visionary Tradition 31

Daniel Defoe and the Re-Imagining of London; William Blake and the Visionary Tradition; Thomas de Quincey and the Origins of the Urban Wanderer; Robert Louis Stevenson and the Urban Gothic; Arthur Machen and the Art of Wandering; Alfred Watkins and the Theory of Ley Lines

2: Paris and the Rise of the *Flâneur* 57

Poe, Baudelaire and the Man of the Crowd; Walter Benjamin and the Arcades Project; Robinson and the Mental Traveller; Psycho-geography & Surrealism

3: Guy Debord and the Situationist International 81

The Pre-Situationist Movements; The Situationist International (1957–1972); Walking the City with Michel de Certeau

4: Psychogeography Today 111

JG Ballard and the Death of Affect; Iain Sinclair and the Rebranding of Psychogeography; Peter Ackroyd and the New Antiquarianism; Stewart Home and the London Psychogeographical Association; Patrick Keiller and the Return of Robinson

Psychogeographical Groups, Organisations and Websites 141

Bibliography & Further Reading 147

Index 153

Introduction

Psychogeography: a beginner's guide. Unfold a street map of London, place a glass, rim down, anywhere on the map, and draw round its edge. Pick up the map, go out into the city, and walk the circle, keeping as close as you can to the curve. Record the experience as you go, in whatever medium you favour: film, photograph, manuscript, tape. Catch the textual run-off of the streets; the graffiti, the branded litter, the snatches of conversation. Cut for sign. Log the data-stream. Be alert to the happenstance of metaphors, watch for visual rhymes, coincidences, analogies, family resemblances, the changing moods of the street. Complete the circle, and the record ends. Walking makes for content; footage for footage.

Robert MacFarlane, *A Road of One's Own*.[1]

Psychogeography. A term that has become strangely familiar – strange because, despite the frequency of its usage, no one seems quite able to pin down exactly what it means or where it comes from. The names are familiar too: Guy Debord and the Situationists, Iain Sinclair and Peter Ackroyd, Stewart Home and Will Self. Are they all involved? And if so, in what? Are we talking about a predominantly literary movement or a political strategy, a series of new age

ideas or a set of avant-garde practices? The answer, of course, is that psychogeography is all of these things, resisting definition through a shifting series of interwoven themes and constantly being reshaped by its practitioners.

The origins of the term are less obscure and can be traced back to Paris in the 1950s and the Lettrist Group, a forerunner of the Situationist International. Under the stewardship of Guy Debord, psychogeography became a tool in an attempt to transform urban life, first for aesthetic purposes but later for increasingly political ends. Debord's oft-repeated 'definition' of psychogeography describes 'The study of the specific effects of the geographical environment, consciously organised or not, on the emotions and behaviour of individuals.'[2] And in broad terms, psychogeography is, as the name suggests, the point at which psychology and geography collide, a means of exploring the behavioural impact of urban place. And yet this term is, according to Debord, one with a 'pleasing vagueness'[3]. This is just as well, because, since his day, the term has become so widely appropriated and has been used in support of such a bewildering array of ideas that it has lost much of its original significance.

Debord was fiercely protective of his brainchild and dismissive of attempts to establish psychogeography within the context of earlier explorations of the city. But psychogeography has resisted its containment within a particular time and place. In escaping the stifling orthodoxy of Debord's situationist dogma, it has found both a revival of interest today and retrospective validation

in traditions that pre-date Debord's official conception by several centuries.

In a book of this size, one must inevitably offer an introduction and an overview rather than an exhaustive analysis and those seeking a meticulous examination of psychogeographical ideas within the strict confines of Debord's schema are likely to be disappointed. I will be discussing the origins and theoretical underpinning of the term but, to my mind, of far greater interest than this often rather sterile debate, is an examination of the literary tradition that psychogeographical ideas have since engendered and out of which they can clearly be shown to have originated. Through this, I have broadened the scope of the book to include separate but allied ideas. So urban wandering will be discussed here alongside the figure of the mental traveller, the flâneur and the stalker. The rigorous and scientific approach of the Situationists will be offset by the playful and subjective methods of the Surrealists. Key figures from the psychogeographical revival, such as Iain Sinclair and Stewart Home, will be preceded by their often unacknowledged forebears, from Blake and de Quincey to Baudelaire and Benjamin. For psychogeography may usefully be viewed less as the product of a particular time and place than as the meeting point of a number of ideas and traditions with interwoven histories. In large part, this history of ideas is also a tale of two cities, London and Paris. Today, psychogeographical groups and organisations (many of whom are listed in an appendix to this book) operate worldwide but the themes

with which this book is concerned rarely stray beyond these two locations.

The reason why psychogeography often seems so nebulous and resistant to definition is that today it appears to harbour within it such a welter of seemingly unrelated elements, and yet amongst this mélange of ideas, events and identities, a number of predominant characteristics can be recognised. The first and most prominent of these is the activity of walking. The wanderer, the stroller, the flâneur and the stalker – the names may change, but from the nocturnal expeditions of de Quincey to the surrealist wanderings of Breton and Aragon, from the situationist *dérive* to the heroic treks of Iain Sinclair, the act of walking is ever present in this account. This act of walking is an urban affair and in cities that are increasingly hostile to the pedestrian, it inevitably becomes an act of subversion. Walking is seen as contrary to the spirit of the modern city with its promotion of swift circulation and the street-level gaze that walking requires allows one to challenge the official representation of the city by cutting across established routes and exploring those marginal and forgotten areas often overlooked by the city's inhabitants. In this way the act of walking becomes bound up with psychogeography's characteristic political opposition to authority, a radicalism that is confined not only to the protests of 1960s Paris but also to the spirit of dissent that animated both Defoe and Blake, as well as the vocal criticism of London governance to be found in the work of contemporary London psychogeographers such as Stewart Home and Iain Sinclair.

Alongside the act of walking and this spirit of political radicalism, psychogeography also demonstrates a playful sense of provocation and trickery. With roots in the avant-garde activities of the Dadaists and Surrealists, psycho-geography and its practitioners provide a history of ironic humour that is often a welcome counterbalance to the portentousness of some its more jargon-heavy proclam-ations. If psychogeography is to be understood in literal terms as the point where psychology and geography intersect, then one of its further characteristics may be identified in the search for new ways of apprehending our urban environment. Psychogeography seeks to overcome the processes of 'banalisation' by which the everyday experience of our surroundings becomes one of drab monotony. The writers and works that will be discussed here all share a perception of the city as a site of mystery and seek to reveal the true nature that lies beneath the flux of the everyday.

This sense of urban life as essentially mysterious and unknowable immediately lends itself to gothic represent-ations of the city. Hence the literary tradition of London writing that acts as a precursor to psychogeography, and which includes writers such as Defoe, de Quincey, Robert Louis Stevenson and Arthur Machen, paints a uniformly dark picture of the city as the site of crime, poverty and death. Indeed, crime and lowlife in general remain a hallmark of psychogeographical investigation and the revival of psychogeography in recent years has been supported by a similar resurgence of gothic forms. Sinclair and Ackroyd are particularly representative of this tendency to dramatise the

city as a place of dark imaginings. This obsession with the occult is allied to an antiquarianism that views the present through the prism of the past and which lends itself to psychogeographical research that increasingly contrasts a horizontal movement across the topography of the city with a vertical descent through its past. As a result, much contemporary psychogeography approximates more to a form of local history than to any geographical investigation.

These then are the broad currents with which psychogeography concerns itself and which the traditions outlined in this book reveal: the act of urban wandering, the spirit of political radicalism, allied to a playful sense of subversion and governed by an inquiry into the methods by which we can transform our relationship to the urban environment. This entire project is then further coloured by an engagement with the occult and is one that is as preoccupied with excavating the past as it is with recording the present.

In outlining these themes and the traditions that support them this book will, in effect, provide a history of psycho-geographical ideas and will be ordered chronologically. It will close in the present day with those writers and filmmakers who have successfully restored psycho-geography to the dominant position it now enjoys, but finding a place to begin is more problematic. I have chosen to place psychogeography within a predominantly literary tradition and, within this broad context, the examination of the relationship between the city and the behaviour of its inhabitants can be seen to be as old as the novel itself. In

English writing, or more particularly in London writing, there is a visionary tradition that is best represented by the motif of the imaginary voyage, a journey that reworks and re-imagines the layout of the urban labyrinth and which records observations of the city streets as it passes through them. The earliest examples of this tradition are in fact pioneering psychogeographical surveys of the city and the first of these was conducted by a pioneer of the novel in English, Daniel Defoe.

Defoe's contribution to the history of psychogeography is twofold. On the one hand his novel *Robinson Crusoe* releases a character who not only haunts the subsequent history of the novel itself but who also provides a curious intersection with the evolution of psychogeography. As we shall see, the figure of Robinson links Defoe to Rimbaud and the flâneur as well as to more recent incarnations of the urban wanderer in the films of Patrick Keiller. But it is in his *Journal of the Plague Year* that Defoe provides the prototype psychogeographical report and, in the process, establishes London as the most resonant of all psychogeographical locations.

Defoe's fictional reconstruction of the plague year of 1665 was written in 1722, some sixty years after the event, and depicts London as an unknowable labyrinth, a blueprint of the city that was to form the basis for later gothic representations. The successful navigation of such a city is dependent upon the composition of a mental map, which can be transposed upon its physical layout, but this mental composition is dislocated by the progress of the plague

which renders a familiar topography strange and threatening. Here, Defoe foreshadows the subjective reworking of the city that the Situationists were to promote and his figure of an urban wanderer, who moves aimlessly across the city before reporting back with his observations, has since become a crucial part of psychogeographical practice.

Defoe inaugurates a tradition of London writing in which the topography of the city is refashioned through the imaginative force of the writer. Peter Ackroyd has described a visionary strand of English writing in which London is overlaid by the fictional and poetic reworking of successive figures, creating patterns of continuity and resonance that can be detected by those attuned to the city's eternal and unchanging rhythms. These 'Cockney Visionaries' are thus able to recognise sites of psychic and chronological resonance and can align these points in order to remap the city. Elsewhere this sense of an eternal landscape underpinning our own has been termed *genius loci* or 'sense of place', a kind of historical consciousness that exposes the psychic connectivity of landscapes both urban and rural. In recognition of such resonance, Defoe is followed by William Blake whose poetry celebrates the spiritual city behind our own, the New Jerusalem whose coordinates he identifies within the streets of the eighteenth-century city. Blake's vision is rooted in his wanderings through the streets, his appreciation of the eternal evident in the familiar and unchanging experiences of its inhabitants. Blake, like Defoe before him, allies this sense of the visionary with the voice of

dissent, his poetry questioning both the political and intellectual systems of his day and promoting the personal and subjective in opposition to the prevailing mechanised and systematic modes of thought. For if the New Jerusalem is to be established, then it must be preceded by the revolutionary overthrow and destruction of the power structures of the day. This call for renewal through revolution was to become the hallmark of situationist thought some two centuries later.

If Defoe and Blake provide the imaginative impetus for psychogeographical ideas, it is Thomas de Quincey who stands as their first actual practitioner. The drug-fuelled ramblings through the London of de Quincey's youth anticipate the aimless drifting and creative revelry of both surrealist and situationist experimentation. De Quincey is the prototype psychogeographer, his obsessive drifting affording him new insights into the life of the city and granting him access to the invisible community of the marginalised and dispossessed. For de Quincey the city becomes a riddle, a puzzle still perplexing writers and walkers to this day, and he establishes a vision of the city replayed by later devotees of the urban gothic such as Robert Louis Stevenson and Arthur Machen. These authors continue the tradition of writer as walker established, at least in urban form, by de Quincey and present the city as a dreamscape in which nothing is as it seems and which can only be navigated by those possessing secret knowledge. This image of the city as subject to arcane and occult knowledge and practices becomes something of a staple in

contemporary psychogeographical accounts. Stevenson's *Jekyll and Hyde* transposes the psychological doubling of the protagonist on to the topography of the city itself, his mental division reflected in an equally divided city in which wealth and respectability conceal the existence of poverty and depravity. And while Stevenson continues in the tradition of the city established by Defoe, Machen extends de Quincey's role as urban wanderer, his explorations of the city's outer limits positioning him as a direct influence upon contemporary psychogeographers such as Iain Sinclair. Machen once again seeks out the strange and otherworldly within our midst – a single street, event or object capable of transforming the most mundane surroundings into something strange or sinister, revealing that point of access, called the Northwest Passage by de Quincey, which provides an unexpected shortcut to the magical realm behind our own.

This strand of visionary London writing is concluded by a figure whose influence upon psychogeography today has been largely overlooked. Alfred Watkins' book *The Old Straight Track* was neglected upon its publication in 1925, but thanks to a revival of interest through the emergence of new age ideas in the 1970s, it has gained an occult significance barely warranted by the original text. It is a study of ley lines, those alignments linking sites and objects of prehistoric antiquity that provide a means of reading the landscape anew. Watkins applied his theory largely to rural landscapes but he did identify some urban leys and it was these that inspired Iain Sinclair in his

celebrated remapping of London through an alignment of those churches designed by the architect Nicholas Hawksmoor.

This is the visionary tradition that takes London as its centre and which has provided a wellspring for many of today's psychogeographic ideas. A home-grown tradition that has completely circumvented the work of Debord and the Situationists but which clearly demonstrates an involvement with many of the same ideas. But my analysis of Debord's ideas is postponed further by the examination of another tradition which, while taking Paris as its starting point, focuses not upon the 1950s but a century before.

Just as London can be shown to have its own tradition of visionary walkers and writers, so one can trace the development of a corresponding tradition on the other side of the Channel. In Paris, the figure of the solitary stroller who both records and comes to symbolize the emergence of the modern city has a name – the *flâneur*.

This figure has become the source of much cultural commentary in recent years and while his existence would appear to provide a clear forerunner for the situationist *dérive*, Debord, clearly anxious to promote the originality of his ideas, was wilfully to overlook the influence of a figure who was, in essence, conducting a psycho-geographical survey of Paris street life some one hundred years earlier.[4]

I will be examining the role of this figure in some detail in a later chapter through a discussion of Baudelaire and Walter Benjamin, in whose work the *flâneur* is first

identified. And yet both these writers acknowledge an earlier portrayal of the detached observer walking the streets, in Edgar Allan Poe's short story *The Man of the Crowd*. This story returns to the streets of London and it is here that the crowd first comes to symbolise the changing nature of the modern city. It was through Baudelaire's translations of Poe that this figure first became equated with a specifically European tradition, for the *flâneur* is not to be associated with the frantic bustle of the London street but with the elegant arcades of Paris. These arcades were soon to be demolished in favour of a more strictly regimented topography and even as the *flâneur* first emerges, he is recognised as a nostalgic figure symbolising not only the birth of the modern city but also the destruction of his former home. The fate of the *flâneur* is bound up with the fate of the city he inhabits and his very existence acts as an indication of the struggles later generations of urban walkers will have to face as the city is redeveloped in a manner increasingly hostile to their activities.

With the street no longer his home the would-be stroller is forced to retreat inwards and to internalise his wandering from the safety of his armchair. The figure of the stationary traveller was to be immortalised in Huysmans' notorious decadent novel *Against Nature (Á Rebours)* in which the domesticated *flâneur* Des Esseintes contrasts the advantages of mental travel with the discomfort of the real thing. Rimbaud was to coin the verb *robinsonner*, meaning to travel mentally, in recognition of this very activity, and as the nineteenth century closes, it becomes increasingly difficult

to distinguish between the figure of the *flâneur* and the mental or stationary traveller. With the rise of the avant-gardes in Paris after the First World War these two concepts were to merge, the Surrealists promoting a brand of automatism in which the urban wanderer is governed solely by the dictates of his unconscious mind. In true Freudian fashion, these unconscious drives were dominated by the sexual impulse and the walks conducted by André Breton, Louis Aragon and others seemed to revolve unerringly around the pursuit of beautiful women. The city had become a primarily erotic location and the prostitute came to represent the female *flâneur* or *flâneuse*. It is in Breton's *Nadja* and Aragon's *Paris Peasant* that we find the blueprint for what has been described as the psychogeographical novel. With their absence of plot and a digressive style that mirrors the aimless journeys they recount, these two novels are the clearest pre-situationist accounts of psycho-geography in action. With its account of Haussmann's redevelopment of the city and the destruction of the arcades, *Paris Peasant* also introduces an element of political protest that first recognises the future role of the urban wanderer, as the detached observer is forced to face up to the destruction of the city and to engage in the struggle against it. Here, in a manner later to be replicated in contemporary critiques of Thatcherite redevelopment in London, Aragon's work demonstrates the future trajectory of psychogeography as it moves away from primarily literary and artistic concerns in favour of a spirit of political intervention. The *flâneur* can no longer stand by the wayside

as an impartial observer, for the destruction of the city demands his opposition to it. The rise of the *flâneur* and the history of the urban wanderer in Paris may be characterised as a process of political awakening. From Baudelaire and Benjamin to Breton and Aragon, Paris is represented as a place of growing unrest and radicalism, and in this new environment the wanderer was soon engaged in an attempt to reclaim the streets.

By the end of the Second World War, the Surrealist movement was effectively finished but the avant-garde in Paris lived on through a number of truly obscure (indeed, barely visible) groups who were increasingly discarding earlier artistic preoccupations in favour of political projects inspired by the prevailing intellectual fashion for Marxist revisionism. It was through one such group, the Lettrist International, that psychogeography first found its way in to print. The first issue of the Lettrist journal *Potlatch* in 1954 contained a 'Psychogeographical Game of the Week' and this was quickly followed in *Potlatch* #2 by Debord's 'Exercise in Psychogeography.' I have included these articles in full in my discussion of Debord but those looking for a cogent expression of psychogeographical ideas will be disappointed by these uninspired offerings. Indeed the Lettrist movement as a whole, while providing a debut for many of the terms later made familiar by the Situationists, remains difficult to take seriously.

In 1957 the Lettrists merged with other even less significant groups and the Situationist International was born. Under Debord's leadership the playful but harmless

activities of the Lettrists soon gave way to a more serious-minded attempt to challenge the bourgeois orthodoxies of the day. As a more rigorous and scientific approach was adopted, at odds with the more subjective style of its predecessors, definitions of the key terms were provided, amongst them Debord's famous definition of psychogeography as well as a detailed account of the roles of the *dérive* and *détournement*. These definitions will be discussed at a later stage in this book, but despite this clear engagement with psychogeography as a tool in the refashioning of the urban environment, it would be quite misleading to equate psychogeography as a single technique with the larger strategies of situationism as a whole. In fact psychogeography only plays a minor role in the history of the Situationist International and after 1960 it was to receive barely any mention at all. Certainly it is noticeable by its absence in the two major theoretical statements of the movement, Debord's *Society of the Spectacle* and Raoul Vaneigem's *The Revolution of Everyday Life* which turn towards a more philosophical engagement with larger questions of society and history. The reasons for psychogeography's apparent demotion are not difficult to find, for behind the endless theoretical statements and manifestos there appears to be next to no actual psychogeographical activity taking place. The style may have changed but these increasingly ambitious pronouncements reveal little more in terms of actual results than the openly ludicrous antics of the Lettrists. The few examples produced are rather fragmentary and mundane descriptions

that read like an outdated travel guide and the Situationists themselves appear to have recognised as much. Soon, their former enthusiasm for psychogeography was to be redirected into Debord's increasingly grandiose plans for world domination. In short, a great deal of legwork was expended for little obvious reward and, as a scientific tool for measuring the emotional impact of urban space, situationist psychogeography must be regarded as an abject failure.

By 1962, further splits resulted in Debord distancing himself even further from the more artistic and subjective components of situationism, that had characterised its early years, in favour of the political radicalism that was to culminate in the Paris uprising of 1968. Ultimately, Debord was to acknowledge that his attempts to fashion psychogeography into a rigorous scientific discipline placed the methodology at odds with the subject of his investigation, as the subjective realm of human emotion remained stubbornly resistant to the objective mechanisms he chose to employ.

As a useful addendum to the lettrist and situationist approach to urban wandering, I have included a brief discussion of a later theoretical account of walking the city in Michel de Certeau's often impenetrable *The Practice of Everyday Life*. Taking New York as his subject, de Certeau provides a useful distinction between the street-level gaze of the walker and the panoptical perspective of the voyeur, but like Debord before him, de Certeau's comments cannot help but demonstrate the clear limitations

theoretical systems face in attempting to capture the often incommunicable relationship between a city and its inhabitants. In this sense, psychogeography is ironically less well served by those theories with which it is most closely associated. The programmatic approach of social theorists and geographers is in this instance unable to accurately reflect the imaginative reworking of the environment that has been conducted so successfully by those writers whose works celebrate contemporary London. And it is these works that I shall be discussing in my final chapter in a return to the city where this account begins.

An indication of the degree to which this subject has today entered the cultural mainstream is to be found in the plethora of internet sites devoted to psychogeography and related ideas. But the roots of this newfound popularity and the corresponding rise of a global psychogeographic community are dependent not upon activists and theorists but are once again grounded in a primarily literary response to our modern technological landscape. As the Situationist movement in Paris petered out, it was in Shepperton that JG Ballard was composing a series of novels depicting the extreme behavioural responses provoked by the new suburban hinterlands of motorways and retail parks. The fictional forays into this suburban non-place, recorded most notoriously in *Crash*, were extremely influential in propelling the focus of psychogeographical investigation outward from the increasingly repackaged heritage cores of the inner city towards the previously overlooked suburban spaces that now encircle all modern cities.

Ballard's cautionary tales of neon-lit nightmare, in which unexpectedly deviant strains of human activity find an outlet, remapped psychogeography's traditional sphere and pointed the way for other writers to re-examine these anonymous and neglected regions. The most implicated successor to Ballard's reworking of the psychogeographical agenda has been Iain Sinclair who, more than any other figure, has been responsible for the rebranding of psychogeography into an accessible and popular format. Sinclair's *Lud Heat*, a meditation upon the occult significance of Hawksmoor's London churches, was to find a wider audience through Peter Ackroyd's deployment of similar ideas in his novel *Hawksmoor* and Sinclair drew heavily upon both the theory of ley lines established by Alfred Watkins and the gothic themes of Stevenson and Machen. Sinclair has been explicit in his resurrection of these earlier traditions, and while his work bypasses the political and theoretical engagement of the Situationists, it is coloured by an impassioned critique of Thatcherite redevelopment of the city. Today, he is the example of writer as walker *par excellence*, his walks in and around the city providing both documentary evidence of political mismanagement and revealing those paranoid conspiracies which have since become the hallmark of modern psychogeography.

Another writer as walker, albeit one who less overtly documents his movements, is Peter Ackroyd, and it is around the Sinclair-Ackroyd axis that most London writing, psychogeographic or otherwise, appears to rotate. Ackroyd's historical re-enactments and panoramic sense of

London's past are coupled to a peculiar theory of chronological resonance in which past events are continuously replayed. These occult concerns display an acute sensitivity to the city's particular spatial and historical connectivity and would appear to establish Ackroyd's position at the heart of London psychogeography. But in reality, Ackroyd's relationship to psychogeographical thought is far more ambivalent. As a direct consequence of his insistence upon London's eternal nature, Ackroyd's position is one of inherent conservatism in which all change is subsumed within this unending historical overview. Such conservatism is, of course, at odds with psychogeography's characteristic political radicalism and, as a result, Ackroyd has distanced himself from the very tradition that his work appears to endorse.

If Ackroyd's espousal of psychogeography is one in which political commitment is sacrificed to historical tradition, then Stewart Home goes some way to reversing this process, positively revelling in his anti-literary position and parodying the current fashion for antiquarianism. Home has positioned himself as a theoretically alert successor to earlier avant-garde practitioners, his promotion of plagiarism, pranksterism and political radicalism recalling the activities of both the Situationists and the Dadaists before them. His output of sexually graphic, ultra-violent anti-novels is as impossible to take seriously as the deployment of Hegelian terminology in his numerous theoretical statements. And yet his involvement in or behind any number of psycho-geographic groups is a reminder of psychogeography's role

as an avant-garde activity as much as simply a literary endeavour and Home's injection of humour is a welcome antidote to the more straight-faced character of much current psychogeographical production.

I have chosen to close my outline of the history and evolution of psychogeographic ideas with a return to the figure with which this account was initiated. Patrick Keiller's films *London* and *Robinson in Space* recall Defoe's hero who, once escaped from the isolation of his desert island, has dogged the history of psychogeography ever since. Keiller's *London* is a meditation upon the city that has remained at the forefront of psychogeography and it describes the degree to which it remains resistant to the role of the wanderer more than a century after the arrival of the *flâneur* in the form of émigré poets such as Apollinaire and Rimbaud. *London* combines a consideration of the failure of this European sensibility to take hold here with an examination of the city's contemporary shortcomings. Typically these failings are perceived to be exclusively the result of Thatcherism but Keiller's films act as a useful corrective to the prevailing sense of psycho-geography as somehow engaged in the protection of the city against the forces of government. Instead Keiller demonstrates the way in which psychogeography has fallen victim to its own success, its rebranding in a newly popular form depriving it of that very spirit of political activism which, as these films demonstrate, has never been so urgently required. Keiller has characterised psycho-geography as increasingly preoccupied with its own

practices as an end in themselves, no longer the tool of any larger political or even cultural project but simply a self-contained and self-immersed movement with little significant impact on the environment whose redevelopment it has so vocally denounced.

Ultimately this introduction to the history, ideas and practice of psychogeography has favoured the literary over the theoretical, preferring to ignore the Situationists' claims for the originality of their own ideas by placing them within the wider historical context that gave rise to them. But this emphasis on the literary should not overshadow the spirit of political protest with which these ideas have traditionally been imbued. Indeed, as we now return to the origins of psychogeography and look in greater detail at the role of Defoe, Blake and the tradition they established, we should recall the degree to which their imaginative vision and their political beliefs were bound together.

Notes

1 Robert MacFarlane, 'A Road of One's Own' *Times Literary Supplement*, October 07, 2005

2 Guy Debord, 'Introduction to a Critique of Urban Geography' in Ken Knabb (Ed) *Situationist International Anthology*, p5

3 Ibid, p5

4 Rebecca Solnit makes this point, commenting: 'That *flâneury* seemed to Debord a radical new idea all his own is somewhat comic.' *Wanderlust*, p212

London and the Visionary Tradition

The triangle of concentration. A sense of this and all the other triangulations of the city: Blake, Bunyan, Defoe, the dissenting monuments in Bunhill Fields. Everything I believe in, everything London can do to you, starts there.

Iain Sinclair, *Lights Out for the Territory*[1]

Like many revolutionary theories anxious to protect their origins from those who might question their attempt to provide a definitive break with the past, psychogeography remains firmly entrenched within a particular time and place: Paris in the 1950s. However, as soon as one looks beyond the narrow context that gave rise to it, it becomes apparent that psychogeography is retrospectively supported (or undermined) by earlier traditions and precursors that have been neglected or wilfully obscured. When we focus upon the predominant characteristics of psychogeographical ideas — urban wandering, the imaginative reworking of the city, the otherworldly sense of spirit of place, the unexpected insights and juxtapositions created by aimless drifting, the new ways of experiencing familiar surroundings — one can soon identify

these themes in the examples of earlier figures whose work pre-dates the formal recognition of the Situationists.

This historical trawl for psychogeographical back-markers has become common practice amongst contemporary writers such as Iain Sinclair, Stewart Home and Peter Ackroyd as they attempt to resurrect and reconnect with earlier literary and historical currents. Any reader of their work will soon become familiar with a small band of the usual suspects who are repeatedly name-checked in their texts and often recruited in support of a specifically English, or more precisely London, tradition. The first of these contenders for psychogeographical progenitor is Daniel Defoe, whose character Robinson is a recurrent figure within the literature of psychogeography. Alongside him we find William Blake, described by Iain Sinclair as the 'Godfather of Psychogeography.'[2] Thomas de Quincey's drug-fuelled wanderings in his *Confessions of an English Opium Eater* were given official recognition by the Situationists themselves[3], while Robert Louis Stevenson's fictional portrayal of London in *The Strange Case of Dr Jekyll & Mr Hyde* was to confirm this city as the most resonant psycho-geographical location of them all. In his *The London Adventure, or the Art of Wandering*, Arthur Machen continued Stevenson's portrayal of the urban gothic, while also providing a blueprint for today's generation of urban wanderers. Finally, alongside these historical and literary figures, we have a writer whose work has possibly been as influential on today's self-proclaimed psychogeographers as Debord and the Situationists themselves. Alfred Watkins *The Old Straight Track*

was originally published in 1925 but it was not until its rediscovery in the 1970s that the theory of ley lines was to become a cornerstone of the new age 'Earth Mysteries' school that has since provided an esoteric counterbalance to the stern revolutionary proclamations of the Situationists.

All these figures can be corralled into a loose allegiance of overlapping themes, whose geographical centre, London, is, together with Paris, one of the two poles of psychogeographical activity. They are linked, however, by more than merely a shared preoccupation with London, reflecting a wider awareness of *genius loci* or 'spirit of place' through which landscape, whether urban or rural, can be imbued with a sense of the histories of previous inhabitants and the events that have been played out against them. Peter Woodcock, in his book *This Enchanted Isle: The Neo-Romantic Vision from William Blake to the New Visionaries*, attempts to map the history of this occult sense of place through the writers and artists that have employed it in their work. He identifies the hallmark of *genius loci* in the Neo-Romantic movement of Paul Nash and other artists who flourished in the inter-war period, but extrapolates their concern with English landscape and identity to develop a tradition that includes Blake and Samuel Palmer as well as contemporary figures such as Sinclair and Keiller. 'Released from its historical location like a ghost in the machine, the *genius loci* has spawned a hybrid of forms,' he writes, concluding that 'The spirit of place is still deeply embedded in our national consciousness... The old Neo-Romantic world has long gone, but the dream persists.'[4]

This dream is one that has been endorsed by Peter Ackroyd, himself a subject of Woodcock's book, who has written at some length upon his belief in *genius loci* and its relationship to English national identity. In a lecture entitled *The Englishness of English Literature* Ackroyd argues that a 'Catholic' strand of English consciousness, one that is exuberant, irrational and, indeed, visionary, has been overlaid and repressed by the protestant rationalism that has prevailed since the Enlightenment. This visionary continuity is described as a 'chronological resonance' and is the point at which place, history and identity converge:

> Just as it seems possible to me that a street or dwelling can materially affect the character and behaviour of the people who live within them, is it not also possible that within our sensibility and our language there are patterns of continuity and resemblance which have persisted from the thirteenth or fourteenth centuries and perhaps even beyond that? And is it not possible that in outlining what I consider to be a buried Catholic tradition, such a pattern can be seen to emerge?[5]

This is a pattern whose emergence today re-routes the orthodoxies of situationism. Ackroyd's 'Cockney Visionaries', from Blake to Sinclair, expose the essence of place obscured by the flux of the everyday and highlight the threat to the identity of the city posed by the banalisation of much urban redevelopment. The figures that I shall be discussing here provide not only a broader historical and literary context, within which psychogeographical ideas

can be judged, but also demonstrate the distance these ideas have travelled since their original conception.

Daniel Defoe and the Re-Imagining of London

Iain Sinclair identifies Bunhill Fields, the Dissenters burial ground, as the focal point of his psychogeography of London, but surely it is Stoke Newington, where Defoe was schooled at the Dissenters Academy and which was later to provide a home for Edgar Allan Poe, that must take precedence as the city's most resonant psychogeographical location. In either case it is the figure of Daniel Defoe (1660–1731) who inaugurates London's long psycho-geographical tradition. With his twin roles as political radical and father of the London novel, Defoe is the first writer to offer a vision of London shaped according to his own peculiar imaginary topography, and in his most famous work, *Robinson Crusoe*, Defoe introduces a character who has haunted both the novel and the literature of psychogeography ever since.

Defoe's extraordinary career as journalist and spy, pamphleteer, poet, travel writer, satirist, economist and merchant is overshadowed by his relatively late foray into the world of the novel, where he is judged by many to have provided the first example of the genre in English. In this sense he illustrates the way in which psychogeographical themes are as old as the novel itself. The novel's staple form of the imaginary journey naturally lends itself to the character of the traveller reporting back from beyond the

bounds of our everyday experience. *Robinson Crusoe*, with its twin motifs of the imaginary voyage and isolation, provides a broad outline of a character who encapsulates the freedom and detachment of the wanderer, the resourcefulness of the adventurer and the amorality of the survivor. In short, all those characteristics necessary for the urban wanderer walking unfamiliar streets. As a consequence, this novel has released a troop of fictional counterparts who populate an extraordinarily diverse range of works, from the novels of Céline and Kafka to the poetry of Weldon Kees and the films of Patrick Keiller.

I shall be discussing the role of Robinson in more detail elsewhere, but while Defoe's most famous creation reappears with an uncanny regularity throughout this account, it is in his *A Journal of the Plague Year* that Defoe can be said to provide what is, in essence, the first psycho-geographical survey of the city. At first glance, Defoe's blend of fact and fiction would appear to have little in common with a set of ideas and practices first named some two hundred years later, but his *Journal,* both in style and content, portrays the city in a manner that shares almost all the preoccupations that have come to be termed psychogeographical. Firstly, Defoe's account of the plague year of 1665 gathers the bare statistical facts, the precise topographical details and the peculiar local testimonies that were to become the hallmarks of psychogeographical investigation and presents them in the non-linear and digressive fashion that was later to characterise the drift of the *dérive.* Furthermore, this blend of fiction and biography,

of local history and personal reminiscence, is bound together to form an imaginative reworking of the city in which the familiar layout of the city is shown to be transformed beyond recognition by the ravages of the plague. Beyond the scenes of individual suffering and mass panic that the plague induced, Defoe's account of London is one of an organic city itself afflicted by disease and, as the plague ebbs and flows, so both Defoe's narrator and the reader find their perception of the city altered as the means of navigating it are gradually obscured. The London that Defoe writes about here and in other London fictions such as *Moll Flanders* is one that describes the medieval core of the city, a labyrinthine layout to be negotiated without the help of street lighting or house numbers. Cynthia Wall writes in her introduction to Defoe's *Journal*: 'Navigating this urban space in the 1660s could be tricky, both physically and conceptually... There *were* no maps for ordinary people to guide them through the city. You made your way by sight, by memory, by history, by advice, by direction – and by luck.'[6]

In the London of this period one traversed the streets through recourse to a mental map established through trial and error and by reading the signs that the environment displayed to you. This alertness to topographical detail and the construction of a mental overview of the city would later form the basis of psychogeographical technique, but in the time of the plague, these techniques became less a choice than a necessity. Only by re-learning the signs as they were rapidly deformed and distorted by the passage of death and disease could Defoe's narrator hope to survive its onslaught.

Defoe reveals a 'sense of a haunted geography'[7] through which the progress of the plague is meticulously documented from street to street and house to house. Soon busy thoroughfares are deserted or blocked off, escape routes emerge only to swiftly disappear and this landscape, with its literal signs of death (the red crosses on the doors marking out a map of contamination), is completely reshaped, becoming alien to the Londoners who had previously prided themselves upon an intimate knowledge of its secrets. This sense of the ground shifting beneath one's feet, as the plague advances and retreats, is mirrored in Defoe's prose style, as a series of digressions and narrative cul-de-sacs afford the reader, both spatially and temporally, that sense of dislocation experienced by the characters. In effect, the catastrophe of the plague creates the characteristic sense of disorientation that we find in all narratives of urban catastrophe, whether caused by warfare, revolution or natural disaster. In such moments the city is momentarily made strange, defamiliarised, as its inhabitants are granted a vision of the city as it might be, as heaven or hell. Of course the Situationists, using psychogeography, also sought a revolutionary cessation of the everyday, hoping, by the imposition of their own imaginative vision, to reveal the city in all its wonder, but it is here in Defoe's account that we are first granted an insight into the ways in which the most familiar geographies may be disrupted.

Defoe was to provide an account of his travels across Britain in his vast *A Tour Through the Whole Island of Great Britain*, and in this work he once again displays an acute

awareness of place as well as accumulating a monumental collection of economic, historical and architectural detail. The format of this book loosely informs Patrick Keiller's film *Robinson in Space* with which my account of psychogeography closes and in this sense this entire project is bookended by Defoe. But it is in London that his sense of place is at its most heartfelt and it is the image of a solitary walker navigating the city and recording his impressions of it that dominates the tradition which he inaugurates.

William Blake and the Visionary Tradition

William Blake of Soho. Child Blake seeing angels in a tree on Peckham Rye. Naked Blake reciting Paradise Lost in a leafy Lambeth bower. Blake the engraver, in old age, walking to Hampstead. Blake singing on his deathbed in Fountain's Court. Blake, lying with his wife Catherine, in Bunhill Fields. Blake the prophet. Blake the psychogeographer. Blake the red-cap revolutionary, watching Newgate burn. Blake the happy-clappy revivalist of Glad Day, banging a tambourine with Michael Horowitz. Blake, at the last night of the proms, burning in the mad eyes of sentimental imperialists.

Iain Sinclair, *Into the Mystic: Visions of Paradise to Words of Wisdom... an Homage to the Written Work of William Blake.*[8]

Iain Sinclair has described William Blake as 'the Godfather of Psychogeography' and, with his emphasis on the imaginative reconstruction of the city, Blake takes his place within a tradition of London writing that foreshadows many of the later psychogeographic preoccupations. Born

in London where he was to spend almost his entire life, William Blake (1757–1827) began his career as an apprentice engraver and student at the Royal Academy. His twofold passions for engraving and poetry were to coalesce to produce a unique body of work – a series of illuminated books in which the battle between the anti-rational forces of the imagination and the repressive and systematic forces of authority is laid bare. Blake's work is bound up with his experiences of the city in which he spent his life to the degree that his identity and that of London itself seem to become indivisible. As he himself claimed in his epic *Jerusalem*, 'My streets are my Ideas of Imagination.'

In his biography of Blake, Peter Ackroyd writes, 'He had a very strong sense of place, and all his life he was profoundly and variously affected by specific areas of London.'[9] Blake was a walker, a wanderer whose poems describe the reality of eighteenth-century street life, but they are overlaid by his own intensely individualistic vision to create a new topography of the city. His legacy to psychogeographic thought here is clear: the transformation of the familiar landscapes of his own time and place into a transcendent image of the eternal city; 'the spiritual Fourfold London eternal.' He is, as Ackroyd has described, a 'Cockney Visionary'[10], whose awareness of London's symbolic existence through time allowed him to perceive the unchanging reality of the city. Thus, in his poem *London*, he wanders the streets witnessing the eternal features of urban life:

> I wander thro' each charter'd street,
> Near where the charter'd Thames does flow.
> And mark in every face I meet
> Marks of weakness, marks of woe.[11]

Blake's superimposition of his peculiar worldview upon the geography of London's streets creates strange juxtapositions between familiar names and locations and visions of a transcendent city. Thus he was able to perceive angels in the unlikely environs of Peckham Rye and gives precise coordinates for the New Jerusalem:

> The fields from Islington to Marybone,
> To Primrose Hill and Saint John's Wood:
> Were builded over with pillars of gold,
> And there Jerusalems pillars stood.[12]

Blake remaps the city as he walks its streets, but if the city is to be rebuilt as Jerusalem, then it must first be destroyed, and his poems abound with apocalyptic imagery that is shaped, not merely by an anti-rationalism and anti-materialism, but also by a strong sense of political radicalism that stands in opposition to authority of every kind. Thus Blake once again pre-empts psychogeographical ideas in his revolutionary call for the destruction of the power structures of his day.

Here, then, we find all the features ascribed to psychogeography today: the mental traveller who remakes the city in accordance with his own imagination is allied to the urban wanderer who drifts through the city streets; the political radicalism that seeks to overthrow the established

order of the day is tempered by an awareness of the city as eternal and unchanging; and the use of antiquarian and occult symbolism reflects the precedence given to the subjective and the anti-rational over more systematic modes of thought.

Thomas de Quincey and the Origins of the Urban Wanderer

Unlike Defoe and Blake, who stand as symbolic representatives of a retrospective psychogeographic tradition, Thomas de Quincey (1785–1859) may be described as psychogeography's first actual practitioner. As Phil Baker has commented, 'Classic urban psycho-geography could almost be said to begin – retrospectively, and from a Situationist influenced perspective – with Thomas de Quincey...'[13]

The drug-fuelled journeys through the London of de Quincey's youth seem to capture exactly that state of aimless drift and detached observation which were to become the hallmarks of the situationist *dérive* some 150 years later.

De Quincey was born in Manchester in 1785 into a prosperous family and was a brilliant student, yet at the age of 17 he ran away to Wales before moving on to London. His early experiences of hardship and observations of the urban underclass were later to be relived in some detail in his *Confessions of an English Opium Eater*. De Quincey wrote the first draft of this work at the

age of 36 and he was to return to it with notes and amendments for the rest of his life, so the experiences recounted in the book are not only coloured by his self-consciously dramatic style but they must also be viewed through the distorting mirrors of both memory and the opium dream itself. For these reasons those wishing to find the harsh realism of the addict's spiral into despair and self-destruction will be disappointed. The *Confessions* are only nominally concerned with addiction and it should be remembered that, in de Quincey's day, opium was both legal and cheaply acquired and had none of the edgy and alienated connotations that might be attributed to drugs today. The *Confessions* should not then be read primarily as an account of drug use but as an exploration of the role of the imagination and the power of dreams to transmute the familiar nature of our surroundings into something strange and wonderful. It is here that de Quincey's true legacy lies and his work can be seen as providing an urban alternative to Wordsworth's evocation of the countryside in *The Prelude*. De Quincey is a prototype for the obsessive drifter, allowing his imagination to shape and direct the perception of his environment; his purposeless drifting at odds with the commercial traffic and allying him to the invisible underclass whose movements map the chaotic and labyrinthine aspects of the city:

> Some of these rambles led me to great distances: for an opium-eater is too happy to observe the motion of time. And sometimes in my attempts to steer homewards,

upon nautical principles, by fixing my eye on the pole-star, and seeking ambitiously for a north-west passage, instead of circumnavigating all the capes and headlands I had doubled in my outward voyage, I came suddenly upon such knotty problems of alleys, such enigmatical entries, and such sphinx's riddles of streets without thoroughfares, as must, I conceive, baffle the audacity of porters, and confound the intellects of hackney-coachmen. I could almost have believed, at times, that I must be the first discoverer of some of these terrae incognitae, and doubted, whether they had yet been laid down in the modern charts of London. For all this, however, I paid a heavy price in distant years, when the human face tyrannized over my dreams, and the perplexities of my steps in London came back and haunted my sleep, with the feeling of perplexities moral or intellectual, that brought confusion to the reason, or anguish and remorse to the conscience.[14]

De Quincey's opium use led to none of the torpor usually associated with the drug, instead seeming to propel him upon his nocturnal wanderings of the city. And this combination of walking and observation, overlaid with a sense of the fantastic and bizarre, proved enormously influential on writers such as Edgar Allan Poe and Charles Baudelaire. These writers, in paying homage to de Quincey, helped to establish the figure of the *flâneur* and, through him, the tradition of French avant-garde writing and theorising that was to continue via the Surrealists to the Situationists. In this way de Quincey influences both the visionary tradition of London writing with which this

chapter is concerned and the figure of the wanderer on the streets of Paris which I shall be discussing in the next.

Robert Louis Stevenson and the Urban Gothic[15]

Modern psychogeographers of the London occult, from Peter Ackroyd to Iain Sinclair and Stewart Home, use gothic imagery to symbolise the mystery beneath the apparently banal surfaces of the everyday city. Through their investigations of the hidden and the marginal and the lines of force that supply a pattern to their findings, these writers employ the occult to political ends, their exposure of hidden sources of power questioning the governance of the city and revealing the plight of the marginalized and dispossessed.

The origins of the London occult that both transforms the topography of the city into something strange and menacing and exposes a double life of privilege and despair lie in the city of the late nineteenth century, a time when writers such as Oscar Wilde, Arthur Conan Doyle and Arthur Machen forever implanted an image of the city as a fogbound labyrinth. More than any other book, however, it is Robert Louis Stevenson's *The Strange Case of Dr Jekyll and Mr Hyde* that formulates this occult division between appearance and reality. First published in 1886, Stevenson's novel soon found a seemingly factual correspondence in the Ripper murders of the following year, forever cementing the two in the public imagination and giving the book an extra-literary existence

somewhere between reality and fiction. Yet Stevenson's novel is much more than merely a traditional horror narrative. Its tale of respectable Dr Jekyll and his disreputable and concealed double Mr Hyde transcends questions of individual psychology to impose its picture of division upon the wider city. Stevenson's London is revealed as having an equally twofold nature – the grand Victorian façades concealing poverty and repression, the wealth of London's West End offset by the squalor and misery to be found in the East. The London that Stevenson creates is an allegorical one, the gaslit streets resonating through a thousand books and films, yet it is one devoid of specific locations and coordinates, a dreamscape that reflects the psychology of the novel's protagonists and a nightmarish image of the city to set against the visions of Blake and de Quincey:

> A great chocolate-coloured pall lowered over heaven, but the wind was continually charging and routing these embattled vapours; so that as the cab crawled from street to street, Mr Utterson beheld a marvellous number of degrees and hues of twilight; for here it would be dark like the back-end of evening; and there would be a glow of rich, lurid brown, like the light of some strange conflagration; and here, for a moment, the fog would be quite broken up, and a haggard shaft of daylight would glance in between the swirling wreaths. The dismal quarter of Soho seen under these changing glimpses, with its muddy ways, and slatternly passengers, and its lamps, which had never been extinguished or had been

kindled afresh to combat this mournful reinvasion of darkness, seemed, in the lawyer's eyes, like a district of some city in a nightmare.[16]

In providing an imaginative topography that would inspire gothic representations of the city for generations to come, Stevenson has been hailed by Robert Mighall as 'the first Psychogeographer'[17] and although I have indicated that there are even earlier claimants to that title, it does seem to me that it has been Stevenson's nightmarish dreamscape that has provided the most lasting image of the city, inspiring an entire tradition of the London Gothic and establishing an unreal but eternal landscape that colours forever our experience of the city.

Arthur Machen and the Art of Wandering

So, here was the notion. What about a tale of a man who "lost his way"; who became so entangled in some maze of imagination and speculation that the common, material ways of the world became of no significance to him?

Arthur Machen, *The London Adventure, or the Art of Wandering.*[18]

Arthur Machen (1863–1947) was born in Gwent and moved to London to pursue a literary career, working variously as a journalist, translator and cataloguer of esoteric literature. Much of Machen's writing is shaped by the enchanted landscapes of his Welsh childhood but this sense of place and an otherworldly awareness of the bizarre

and the fantastic was soon to be transported to the streets of his adopted city. Machen was to take the 'Ars Magna of London', the 'Great Art' of the city as the source for much of his writing, and in his early gothic works the familiar streets of city were shown to conceal a world of supernatural significance.

In both *The Great God Pan* and *The Three Impostors* Machen was to continue Robert Louis Stevenson's legacy by portraying a gothic London where nothing is as it seems and where the mundane and the familiar obscure the true nature of the city:

> Here, then, is the pattern in my carpet, the sense of the eternal mysteries, the eternal beauty hidden beneath the crust of common and commonplace things; hidden and yet burning and glowing continually if you care to look with purged eyes... I think it is easier to discern the secret beauty and wonder and mystery in humble and common things than in the splendid and noble and storied things.[19]

For Machen, the trained eye can reveal the eternal behind the commonplace. He is indebted to Stevenson for the use of this observation within a fictional setting, but London was to provide Machen with much more than merely inspiration for his writing. In essence, it provided him with a new means of experiencing his environment. Machen, like de Quincey before him, stands within a tradition of writer as walker and his representation of the London streets is informed as

much by autobiography as it is by imagination. And it is in these wanderings through the city that Machen becomes a prototype for both the *flâneur*[20] and for today's breed of psychogeographer. Early novels in which the characters do the walking were soon to give way to autobiographical tales in which it is Machen himself who walks the city streets. In books such as *Things Near and Far* and *The London Adventure* Machen narrates his own adventures within those 'raw, red places all around the walls of London', outlining his peculiar 'London science' in which the aim is to 'utterly shun the familiar'[21] in favour of a deliberate attempt to lose oneself amongst the overlooked quarters of the city.

This conscious attempt to ignore the known aspects of the city in favour of an aimless wandering, driven solely by the force of the imagination, indicates the degree to which Machen is a hybrid figure in which writer and walker merge. By allowing himself to commune with the strangeness of his surroundings, Machen was to discover the delights of mental travel in which the exotic was literally to be found upon one's doorstep and where the lure of the foreign was to be rendered redundant by the promise of experiences to be found closer to home:

> And it is utterly true that he who cannot find wonder, mystery, awe, the sense of a new world and an undiscovered realm in the places by the Gray's Inn Road will never find those secrets elsewhere, not in the heart of

Africa, not in the fabled hidden cities of Tibet. "The matter of our work is everywhere present," wrote the old alchemists, and that is the truth. All the wonders lie within a stone's-throw of King's Cross Station... I will listen to no objections or criticisms as to the Ars Magna of London, of which I claim to be the inventor, the professor and the whole school. Here I am artist and judge at once, and possess the whole matter of the art within myself. For, let it be quite clearly understood, the Great Art of London has nothing to do with any map or guide-book or antiquarian knowledge, admirable as these things are... But the Great Art is a matter of quite another sphere; and as to maps, for example, if known they must be forgotten... And all historical associations; they too must be laid aside... Of all this the follower of the London Art must purge himself when he sets out on his adventures. For the essence of this art is that it must be an adventure into the unknown, and perhaps it may be found that this, at last, is the matter of all the arts.[22]

Ultimately, Machen is outlining the practice of psychogeography in these remarks, for as he frees himself from all geographical or historical markers, Machen remaps the city as he passes through it, and in establishing a trajectory away from the more well-trodden centre toward the overlooked suburban quarters of the city, Machen points the way for today's generation of psychogeographers as they explore London's anonymous outer limits.

Alfred Watkins and the Theory of Ley Lines

... imagine a fairy chain stretched from mountain peak to mountain peak, as far as the eye could reach, and paid out until it touched the "high places" of the earth at a number of ridges, banks, and knowls. Then visualize a mound, circular earthwork, or clump of trees, planted on these high points, and in low points in the valley other mounds ringed round with water to be seen from a distance. Then great standing stones brought to mark the way at intervals, and on a bank leading up to a mountain ridge or down to a ford the track cut deep so as to form a guiding notch on the skyline as you come up... Out from the soil we wrench a new knowledge, of old, old human skill and effort, that came to the making of this England of ours.

Alfred Watkins, *The Old Straight Track*[23]

The theory of ley lines is less a precursor to psycho-geography than an indication of the degree to which the latter has become entangled amidst a confusion of new age and esoteric ideas, bearing little, if any, resemblance to Debord's original conception.

Alfred Watkins (1855–1935) discovered his theory in a single revelatory insight whilst riding in the Herefordshire countryside on 30 June 1921. A somewhat unlikely prophet for new age ideas, Watkins spent much of his life as a sales rep for a local brewer, a biographical fact that was no doubt seen by his detractors as revealing the source of much of his inspiration. Years of travelling across the Herefordshire countryside developed Watkins' interest in local history and customs and, at the age of 65, he suddenly

perceived this familiar landscape to be covered by a vast network of straight tracks, aligned through the hills, mounds and other landmarks. This moment of inspiration resulted in *Early British Trackways* and later *The Old Straight Track* in which he propounded, in a sober and deliberate fashion, his argument for the existence of this prehistoric network.

Needless to say, Watkins' ideas were regarded as heretical by the archaeological establishment and, after the initial controversy had died down, they were soon forgotten. With the rise of new age philosophies in the 1960s, however, a new interest in antiquarianism emerged in tandem with an increasingly esoteric world-view. The publication of John Michell's *The View Over Atlantis* was extremely influential in establishing the popularity of an amalgam of new age practices and it was against this backdrop that Watkins's work was rediscovered, and *The Old Straight Track* was reissued in 1970. Soon a densely written and researched obscurity had acquired an occult popularity at odds with its actual content.

'My main theme,' writes Watkins, 'is the alignment across miles of country of a great number of objects, or sites of objects, of prehistoric antiquity. And this not in one or a few instances, but in scores and hundreds. Such alignments are either facts beyond the possibility of accidental coincidence or they are not.'[24] Watkins' theory is a straightforward one, backed up by numerous examples, and yet many of his claims have been dismissed on the grounds that because there is such a wealth of

prehistoric sites in this country, some of them are bound to form a suggestive pattern of some description. Equally, allowing for the veracity of Watkins' schema, it is far from clear if such a mapping of the landscape indicates any religious or occult significance or whether it simply reflects trade routes or navigational points.

These investigations are not solely concerned with rural locations and Watkins does touch upon the existence of urban leys, commenting: 'There are curious facts linking up orientation with the ley system illustrated by some London churches.'[25] This is the point at which Watkins' discoveries intersect with psychogeography as it is understood today and the proposal of an occult pattern encompassing Hawksmoor's six remaining London churches forms the basis of Iain Sinclair's *Lud Heat*. Famously, Peter Ackroyd followed Sinclair's lead in his novel *Hawksmoor*, but in both cases these alignments are given a blend of occult paranoia wholly lacking in Watkins' text. Here Watkins' work can be read alongside Elizabeth Gordon's earlier book, *Prehistoric London: Its Mounds and Circles*, in developing a theory which, although acknowledged by today's generation of psychogeographers, completely bypasses the work of Debord and the Situationists. In the years since its original publication, Watkins' work has been placed under the pseudo-scientific umbrella of the 'Earth Mysteries' school with its sponsorship of esoteric practices, from dowsing to geomancy, and ley lines have found themselves mutated into lines of 'force' or 'power'. The exact nature of this force or power remains unclear, but this reworking of

Watkins' original notion mirrors the reinterpretation of psychogeography itself which has been similarly distanced from its origins.

The precursors I have explored in this chapter all take their place within a visionary strand of a specifically English tradition. From Blake to de Quincey and on to Watkins himself, these figures celebrate the *genius loci* in both the otherworldliness of the English countryside and the labyrinthine complexity of London. However, the origins of psychogeography are not solely located in an English tradition and these figures and their works are complemented by the activities of those on the other side of the Channel who stroll the streets of Paris.

Notes

[1] Iain Sinclair, *Lights Out for the Territory*, p34

[2] Ibid, p54

[3] The unnamed author of 'Unitary Urbanism at the End of the 1950s' writes: 'Thomas de Quincey's real life from 1804–1812 makes him a precursor of the *dérive*.' See *Internationale Situationniste #3* at www.notbored.org/ UU.html

[4] Peter Woodcock, *This Enchanted Isle*, p139–141

[5] 'The Englishness of English Literature' in Peter Ackroyd, *The Collection*, p 328–341

[6] Cynthia Wall (Ed), Daniel Defoe *A Journal of the Plague Year*, Introduction, pxxiv

[7] Ibid, pxxv

[8] Iain Sinclair, 'Into the Mystic: Visions of Paradise to

Words of Wisdom... an Homage to the Written Word of William Blake.' *The Observer*, Sunday October 22, 2000

9 Peter Ackroyd, *Blake*, p20

10 Ibid, p91

11 William Blake, 'London' *Complete Writings*, p216

12 William Blake, 'Jerusalem' *Complete Writings*, p649

13 Phil Baker, 'Secret City: Psychogeography and the End of London' in Kerr & Gibson (Eds) *London from Punk to Blair*, p326

14 Thomas de Quincey, *Confessions of an English Opium Eater*, p81

15 In my summary of Stevenson I have drawn heavily upon Robert Mighall's introduction to Stevenson's novel. See Robert Mighall (Ed) Robert Louis Stevenson, *The Strange Case of Dr Jekyll and Mr Hyde*, Introduction pix-xxxviii

16 Robert Louis Stevenson, *Jekyll and Hyde*, p23

17 Robert Mighall, pxxxi

18 Arthur Machen, *The London Adventure, or the Art of Wandering*, p141

19 Ibid, p75

20 As David Trotter notes, Machen was familiar with this term, describing in the story 'A Fragment of Life,' 'the innumerable evenings on which he had rejected his landlady's plain fried chop, and had gone out to flâner among Italian restaurants in Upper Street...' See David Trotter (Ed) Arthur Machen, *The Three Impostors*, Introduction, pxxii

21 Arthur Machen, *The London Adventure*, p49

22 Arthur Machen, *Things Near and Far* in Palmer (Ed) *The Collected Arthur Machen*, p323

23 Alfred Watkins, *The Old Straight Track*, p218

24 Ibid, Introduction pxx

25 Ibid, p133

Paris and the Rise of the *Flâneur*

> *What exactly a* flâneur *is has never been satisfactorily defined, but among all the versions of the flâneur as everything from a primeval slacker to a silent poet one thing remains constant: the image of an observant and solitary man strolling about Paris.*
>
> Rebecca Solnit, *Wanderlust*[1]

If psychogeography can be shown to have germinated within an earlier tradition which celebrates the writer as walker, then this tradition must be viewed as a tale of two cities. As we have seen through such examples as de Quincey and Stevenson, London becomes emblematic of the city as labyrinth, a darkly gothic vision in which the mundane reality of everyday life masks the eternal city that lies beneath. And yet when we think of the *flâneur*, whose aimless strolling is elevated to an art form, it is not the menacing and overcrowded thoroughfares of London that spring to mind but rather the elegant arcades of nineteenth-century Paris.

Today the *flâneur* has become a somewhat overworked figure, beloved of academics and cultural commentators,

but while he (the *flâneur* is invariably seen as male) remains inseparable from the Paris of his day, his origins remain obscure. Baudelaire is credited with providing the first description of the figure in his essay of 1863, *The Painter of Modern Life*. Later, Walter Benjamin was to offer an analysis of the *flâneur* and his relationship to modernism in his fragmentary and incomplete account of nineteenth-century Paris, *The Arcades Project*, a work that was to establish his position as the 'patron saint of cultural studies.'[2]

Both Baudelaire and Benjamin locate the *flâneur*'s literary conception within a short story by Edgar Allan Poe. Written in 1840, *The Man of the Crowd* ironically returns us to the streets of London and it is one of the earliest examples of the use of the crowd as a symbol for the emerging modern city, exploring the role of the detached observer who becomes intoxicated by its movement. Yet, even here, the *flâneur*, the 'hero' of the modern city, is already showing signs of his own demise. From the outset the *flâneur* is a nostalgic figure, who, in proclaiming the wonders of urban life, also acknowledges the changes that threaten to make the idle pedestrian redundant. It is only with the advance of the avant-garde between the wars and, in particular, with the rise of surrealism that the role of the *flâneur* is salvaged and he is restored to his rightful position wandering the Paris streets. The Surrealists provide an account of a new kind of wanderer, alive to the potential transformation of the city and engaged in those subversive and playful practices

that were later to become the hallmark of the Situationists. Here, once again, the wanderer whose movements transform his surroundings provides a link with a lost tradition that reclaims the city as the site for political and aesthetic experimentation.

In this chapter I will be discussing these figures, movements and their works, and alongside the figure of the *flâneur*, I will also discuss his less celebrated counterpart, Robinson, the mental traveller, a figure first identified by Baudelaire's successor Rimbaud, and whose armchair travels provide further links with today's brand of psychogeography.

Poe, Baudelaire and the Man of the Crowd

Born in Boston in 1809 and briefly a schoolboy in Stoke Newington in London (1815–20), Edgar Allan Poe spent the remainder of his life on the East coast of the USA. Within the context of psychogeographic ideas it is tempting to see Poe as representative of an American tradition of psychogeography and thus to expand the origins of this concept beyond London and Paris, but in reality Poe is less at home within an American tradition than he is within a European one. His most famous creation, the prototype detective Dupin, plies his trade in Paris where he solves *The Mystery of the Rue Morgue*, while *The Man of the Crowd* takes London as a fictional setting and Poe was heavily influenced by the European Romantic tradition. Through the translations of Baudelaire, his work influenced later writers

such as Rimbaud and was instrumental in establishing the *flâneur* as a European figure.

Baudelaire and, later, Walter Benjamin specifically cite Poe's story as inaugurating a new urban type, an isolated and estranged figure who is both a man of the crowd and a detached observer of it and, as. such, the avatar of the modern city. A man sitting in a coffee house watches the passing crowds as they throng a busy London street. This passive observer catches a glimpse of a man with a strange visage and, his curiosity aroused, he sets off in pursuit. As he follows, he is led on a seemingly aimless and haphazard journey across the city from its centre to its less salubrious suburbs. Night follows day and this pursuit continues until finally, feeling that the journey will never end, our narrator approaches his quarry and stops him. The man barely notices him and simply continues on his way: 'This old man, I said at length, is the type and the genius of deep crime. He refuses to be alone. He is *the man of the crowd*. It will be vain to follow; for I shall learn no more of him, nor his deeds.'[3]

In these few pages, then, we witness the emergence of the *flâneur*, the wanderer in the modern city, both immersed in the crowd but isolated by it, an outsider (even a criminal) yet ultimately a man impossible to fathom and one whose motives remain unclear. This wanderer heralds both the emergence of a new type of city and the passing of the old, his aimless wandering already at odds with his surroundings and his natural habitat threatened, in Paris at least, by the emergence of a more regimented topography.

Baudelaire describes Poe's story as a picture, 'painted – or rather written by the most powerful pen of our age'[4] and, through his interpretation of this figure and his transportation from London to Paris, he is able to fashion what amounts to the closest we come to a definitive account of his, often contradictory, nature:

> The crowd is his element, as the air is that of the birds and water of fishes. His passion and his profession are to become one flesh with the crowd. For the perfect *flâneur*, for a passionate spectator, it is an immense joy to set up house in the heat of the multitude, amid the ebb and flow of movement, in the midst of the fugitive and the infinite. To be away from home and yet to find oneself everywhere at home; to see the world, to be at the centre of the world, and yet remain hidden from the world…[5]

For Baudelaire, Paris becomes a book to be read by walking her streets, yet the labyrinthine and essentially medieval topography that is still largely intact in London was soon to be destroyed in Paris as Baron Haussmann's wholesale reconfiguration of the city was to sever the links between large swathes of the populace and the city they inhabited. In this environment the *flâneur* is under threat and Baudelaire responds by creating an idealised figure, and an idealised city, in which everyone conforms to some degree to the figure of the *flâneur* but no-one actually attains his elusive status. For, as the historian of walking, Rebecca Solnit, has commented, 'The only problem with the *flâneur* is that he did not exist, except as

a type, an ideal, and a character in literature... no one quite fulfilled the idea of the *flâneur*, but everyone engaged in some version of *flâneury*.'[6]

The *flâneur* is elusive to the point that he cannot be located at all, but the search for this figure itself takes on the characteristics of *flâneury* and offers new ways of experiencing the city. Like London before it, Paris in the nineteenth century had expanded to the point where it could no longer be comprehended in its entirety. It had become increasingly alien to its own inhabitants, a strange and newly exotic place to be experienced more as a tourist than as a resident. Soon the city becomes characterised as a jungle, uncharted and unexplored, a virgin wilderness populated by savages demonstrating strange customs and practices. The navigation of this city becomes a skill, a secret knowledge available only to an elect few, and in this environment the stroller is transformed into an explorer, or even a detective solving the mystery of the city streets. As these streets are gradually destroyed and reordered, so this wilderness is tamed and domesticated and the walker's arcane knowledge is rendered obsolete. As public spaces become private ones and the street is choked with traffic, so walking is reduced to mere promenading, explorers becoming little more than window-shoppers. In the modern city the man of the crowd must adapt or perish.

Walter Benjamin and the Arcades Project

Not to find one's way in a city may well be uninteresting and banal. It requires ignorance — nothing more. But to lose oneself in a city — as one loses oneself in a forest — that calls for quite a different schooling. Then signboards and street names, passers-by, roofs, kiosks, or bars must speak to the wanderer like a cracking twig under his feet, like the startling call of a bittern in the distance, like the sudden stillness of a clearing with a lily standing erect at its centre. Paris taught me this art of straying.

Walter Benjamin, *A Berlin Chronicle*.[7]

Baudelaire equates Poe's *Man of the Crowd* with the *flâneur* but Benjamin challenges this position by arguing that the London that Poe describes, with its overcrowded thoroughfares, cannot support the aimless movement of the *flâneur*. The detached composure of the true stroller instead gives way to manic and uncontrolled behaviour more akin to a stalker: 'He is as much out of place in an atmosphere of complete leisure as in the feverish turmoil of the city. London has its man of the crowd.'[8]

Benjamin's unfinished magnum opus, *The Arcades Project*, offers a series of fragmentary insights into life in nineteenth-century Paris and takes its title from the series of spectacular glass enclosed arcades that were the highlights of the city. These emporiums were the threatened environment of the dandified stroller and were destroyed by Baron Haussmann's redevelopment of the city, as the arcades gave way to the boulevards of modern Paris. Benjamin repeatedly returns to Baudelaire and to

the *flâneur* as symbolic of a bygone age and yet he sees Poe's character as a specifically London figure, not a prototype of the *flâneur* on the streets of Paris but rather a portrayal of the fate of the *flâneur* in the machine age. For amidst the unseen processes of the industrial city, the *flâneur* is reduced to little more than a cog in the machine, an automaton governed by the pressures of a barbaric crowd, not so much the hero of modernism as its victim. This is the fate that Benjamin recognises in Baudelaire's tragic existence, not the model for the *flâneur* but the victim of an uncaring mechanism. For Benjamin, the *flâneur* is unable to maintain his detachment and is inevitably caught up by the commercial forces that will eventually destroy him:

> The crowd was the veil behind which the familiar city as phantasmagoria beckoned to the *flâneur*. In it, the city was now landscape, now a room. And both of these went into the construction of the department store, which made use of *flânerie* itself in order to sell goods. The department store was the *flâneur*'s final coup.[9]

The role of window-shopper is thus both the high point and the death knell for the *flâneur*, but once the crowds have thinned and the mystery evaporated, the *flâneur* remains vigilant, and behind his indolent and narcissistic image, he retains his subversive nature: 'The *flâneurs* liked to have the turtles set the pace for them. If they had had their way, progress would have been obliged

to accommodate itself to this pace.'[10]

The *flâneur* may be a symbol of the city as shopping mall but this insistence upon a walker's pace questions the need for speed and circulation that the modern city promotes (yet seldom achieves). The wanderer remains essentially an outsider opposed to progress and while 'the bazaar is the last hangout of the *flâneur*'[11] he remains, at least, a non-paying customer.

Ultimately, the *flâneur* is a composite figure – vagrant, detective, explorer, dandy and stroller – yet, within these many and often contradictory roles, his predominant characteristic is the way in which he makes the street his home and this is his true legacy to psychogeography. Yet the history of the *flâneur* is one in which the cities that he inhabits are shown to be increasingly hostile to him, and he is ultimately evicted from the street and forced to seek a new environment elsewhere. Benjamin describes Paris as a city 'which had long since ceased to be home to the *flâneur*'[12], but as he became increasingly hedged in and barred from the streets, the would-be wanderer devised new methods of travel that could be conducted from the safety of one's own armchair. Soon the mental traveller, immortalised by Blake, was to make an unexpected comeback and the *flâneur*'s disreputable and rather less well known cousin, Robinson, was to emerge.

Robinson and the Mental Traveller

My room is situated on the forty-fifth degree of latitude... it stretches from east to west; it forms a long rectangle, thirty-six paces in circumference if you hug the wall. My journey will, however, measure much more than this, as I will be crossing it frequently lengthwise, or else diagonally, without any rule or method. I will even follow a zigzag path, and I will trace out every possible geometrical trajectory if need be.

Xavier de Maistre, *A Journey Around My Room.*[13]

In the spring of 1790, Xavier de Maistre, confined to his room under house arrest, embarked upon a voyage around his bedroom, a trip every bit as arduous as that of Magellan and Cook but one that took place almost entirely within the boundaries of his own imagination. The result was *A Journey Around My Room* and it was followed by the equally adventurous *A Nocturnal Investigation Around My Room*. These accounts, as de Maistre was to proudly proclaim, would introduce the world to a new form of travel involving little of the risk or expense facing the conventional traveller. 'There's no more attractive pleasure,' claims de Maistre[14] 'than following one's ideas wherever they lead, as the hunter pursues his game, without even trying to keep to any set route. And so, when I travel through my room, I rarely follow a straight line: I go from my table towards a picture hanging in a corner; from there I set out obliquely towards the door; but even though, when I begin, it really is my intention to go there, if I happen to meet my

armchair en route, I don't think twice about it, and settle down in it without further ado.'

De Maistre's sedentary journey, an early example (perhaps the earliest) of stationary travel, anticipates the fate of the *flâneur*, himself reduced to circling his room, the hostility of the modern city forcibly replacing the street with his armchair and thereby internalising his wandering. This image of the housebound *flâneur* increasingly cast adrift from his familiar surroundings is given fictional form in Joris-Karl Huysmans' notorious decadent novel *Against Nature (À Rebours)*. Published in 1894, Huysmans' celebrated account of arch-dandy and domesticated *flâneur*, Duc Jean Floressas des Esseintes, was the novel that Oscar Wilde used as a textbook for his *Dorian Gray*, and it is this sickly and indolent aesthete, surrounded by the trappings of his luxurious home and unable to muster the energy to walk the streets, who stumbles upon the advantages of mental travel. Des Esseintes, fuelled by the novels of Charles Dickens, formulates an energetic plan to visit London for himself. Having ordered a taxi and visited an English tavern in Paris, however, he finds himself unable to complete his journey and, exhausted, he returns home. Yet he realises that the imaginary journey he has undertaken is a more than preferable substitute for the real thing:

'Get up, man, and go,' he kept telling himself, but these orders were no sooner given than countermanded. After all, what was the good of moving, when a fellow could travel so magnificently sitting in a chair? Wasn't he already

in London, whose smells, weather, citizens, and even cutlery, were all about him? What could he expect to find over there, save fresh disappointments... As it is, I must have been suffering from some mental aberration to have thought of repudiating my old convictions, to have rejected the visions of my obedient imagination, and to have believed like any ninny that it was necessary, interesting, and useful to travel abroad.[15]

Both de Maistre and Huysmans direct us toward a new form of wandering that promotes mental travel in preference to that conducted in the street. The verb *flâner* has been defined as *Errer sans bout, en s'arrêtant pour regarder* which translates as 'wandering without aim, stopping once in a while to look around'.[16] And yet, as these examples demonstrate, travel in late nineteenth-century Paris increasingly approximates to another verb, reputedly coined by Arthur Rimbaud, *robinsonner*, which means 'to let the mind wander or to travel mentally.'[17]

Robinsonner refers back to Defoe's *Robinson Crusoe* with its twin themes of the imaginary voyage and isolation, and in the figure of Robinson we find the model for the urban wanderer in the modern city, a figure who, like Rimbaud himself, is a mental traveller with the ability to survive in hostile territory. If Robinson has a familiar ring to him then it is because this figure has undertaken a literary journey since Defoe's day to become something of an emblem for today's psychogeographer, linking the *flâneur* of nineteenth-century Paris with the urban wanderers of contemporary London. Defoe, as I have discussed in the

preceding chapter, is a figure who returns us to the origins of psychogeography and, consequently, the origins of the novel itself. His most famous creation is something of a literary revenant who returns through a cycle of novels and films from *Robinson Crusoe* to Patrick Keiller's *Robinson in Space*, in the process tracing out the evolution of psychogeography.

Rimbaud's *robinsonner* both defines the role of the mental traveller in the fictions of de Maistre and Huysmans, as well as reflecting his own experiences as *flâneur*-in-exile on the streets of London. For Rimbaud, along with fellow expatriates Verlaine, Mallarmé and Apollinaire, represent the moment that the *flâneur* crosses the Channel, joining the visionary tradition of Blake and Defoe to the lineage of Poe and Baudelaire and providing the urban wanderer with a new role. These figures, exiled renegade poets leading marginal and disreputable existences within the city, act as templates for the fictional role that Robinson was to play in the coming century. Thus, in Kafka's *Amerika (The Man Who Disappeared)*, we see a character named Robinson, an exiled European and shameless chancer, lead a picaresque and haphazard journey across a country that the author never visited. A few years later, in Céline's *Journey to the End of the Night,* we once again witness the travels of an elusive character named Robinson who inhabits the margins of a story that is really a journey, or series of journeys, guided only by the vagaries of the author's own experiences. In an epigraph to his novel, Céline writes: 'Travel is very useful and it exercises the imagination. All the rest is

disappointment and fatigue. Our own journey is entirely imaginary. That is its strength.'[18] Once again a journey is given meaning only through the intervention of its author's imagination and the wanderer is represented by an émigré European with an unreliable past. This is the unfolding history of the *flâneur*, expelled from the streets and the city, even from the continent, but continuing to wander, in rather reduced circumstances, and compelled to bear witness to what he sees.

Weldon Kees was a man who, like Kafka's hero, really did disappear, vanishing for good in 1955. His series of poems about Robinson survive, however, continuing the journey of this enigmatic figure as he juggles identities across time and space:

> Observant scholar, traveller,
> Or uncouth bearded figure squatting in a cave,
> Keen-eyed sniper on the barricades,
> A heretic in catacombs, a famed roué,
> A beggar on the streets, the confidant of popes –

All these are Robinson in sleep, who mumbles as he turns, "There is something in this madhouse that I symbolize – This city – nightmare – black –"[19]

From stationary traveller to sleeping traveller, Robinson continues to wander even as he dreams and, after a journey spanning continents and centuries, Robinson finally returns home to the streets of contemporary London. In

his novel *Robinson*, filmmaker and sometime collaborator of Iain Sinclair, Chris Petit, offers a vision of London as film location in which Robinson emerges as a filmmaker who criss-crosses the city following an unknown agenda. Here, Robinson becomes an updated version of Poe's *Man of the Crowd*, a deranged voyeur with a camera, shadowing the streets of Soho in search of a shot that will make sense of his weakening grasp on reality. He is a figure who retains the detachment of the *flâneur* but for whom the boundaries between reality and imagination have become blurred: 'He was both as substantial and as thin as a character in a movie. Robinson was there all right, a character, but all the little things about him... suggested someone outside everything.'[20]

Finally, as Petit's novel anticipates, Robinson makes the transition from book to film as the protagonist of Patrick Keiller's *London* and *Robinson in Space*. In these two films, Keiller updates Defoe's journeys around London and the UK to the 1990s, in this case following Robinson and his unnamed companion as they provide a commentary on the state of the nation. I will be returning to these films in a later chapter but they take their place here as the most recent point on a fictional journey that begins with Defoe and which traces the evolution of the urban wanderer in all his guises, from mental traveller and armchair dreamer to *flâneur*, vagrant and stalker. Robinson is a totemic figure mapping out his own journey from text to text, from literature to film, providing a parallel history of urban wandering as it moves from London to Paris and around

the world. Here we see writ in miniature the development of psychogeography, as it mutates from detached observation to a more committed and involved practice engaged with its surroundings and increasingly determined to change them. This history culminates in the activities of the Situationists, but the mood of political radicalism and subversive experimentation can itself be traced back to the avant-garde practices of an earlier generation and, in particular, to the rise of surrealism.

Psychogeography & Surrealism

We are doubtless about to witness a complete upheaval of the established fashions in casual strolling and prostitution.

Louis Aragon, *Paris Peasant.*[21]

If the *flâneur* celebrated by Baudelaire and Benjamin is merely a passive observer detached from his surroundings, then his female counterpart, the *flâneuse*, is ascribed a quite different role, that of the prostitute. The Parisian arcades are repeatedly identified as the haunts of both prostitutes and their clients, amongst them Benjamin and Baudelaire and, as we shall see, the prime movers of the Surrealist movement. As we approach the avant-garde flowering of the inter-war period, the streets of Paris are increasingly characterised as an erotic location – a place to procure, seek out or simply think about sex.[22]

Surrealism is usually dated from the publication of André Breton's *Manifesto of Surrealism* in 1924, but it was in 1918

that two of its key members, André Breton and Louis Aragon, first met, and between them, they were to produce the closest we have yet come to what has been described as the psychogeographical novel.[23] With their absence of plot and digressive style, Breton's *Nadja* and Aragon's *Paris Peasant* offer accounts of journeys conducted through the Paris streets which are governed, in varying degrees, by sexual desire, and in their aimless strolling, they provide not only a precursor to the situationist *dérive* but a blueprint for contemporary wanderers on the streets of London.

André Breton, surrealism's arch-theorist, offers a definition of surrealism in his 1924 *Manifesto* when he writes: 'I believe in the future resolution of these two states, dream and reality, which are seemingly so contradictory, into a kind of absolute reality, a *surreality*, if one may so speak.'[24] Surrealism, like its forebear the Dada movement, and in common with many of the avant-garde groups that flourished in the aftermath of WWI, was guided not merely by the aim of producing works of art, but by the hope of transforming our experience of everyday life and replacing our mundane existence with an appreciation of the marvellous. In short, surrealism's domain was the street and the stroll was a crucial practice in its attempt to subvert and challenge our perceptions. It is through this stated aim of reconciling the contradictory roles of everyday reality and unconscious desire that the figures of the *flâneur* and Robinson begin to coalesce, forging a figure whose journey through the streets is both directed and transformed by the dictates of these unconscious drives.

The surrealist practice of automatism, in which the unconscious was given free rein, was not simply confined to automatic writing but also extended to walking. The aimless drifting that was later to become the *dérive* was initiated here in a series of walks whose free-floating exploration of Paris was designed to 'remedy the incompetence of guides... and to discover the places that really have no reason to exist.'[25] It is this open-ended geographical automatism that characterises Breton's *Nadja*, a largely autobiographical account whose mysterious heroine was inspired by one of the writer's actual lovers, who, in true surrealist fashion, ended her days in an asylum. *Nadja* has been described as 'a psychogeographical novel *par excellence*'[26], a surrealist romance filled with those correspondences, coincidences and uncanny juxtapositions that characterised the movement. Breton's account is dominated by the spontaneous and unexpected and reflects an outlook in which chance governs all:

Perhaps life needs to be deciphered like a cryptogram. Secret staircases, frames from which the paintings quickly slip aside and vanish (giving way to an archangel bearing a sword or to those who must forever advance), buttons which must be indirectly pressed to make an entire room move sideways or vertically, or immediately change its furnishings; we may imagine the mind's greatest adventure as a journey of this sort to the paradise of pitfalls.[27]

Nadja is attuned to the voices of the past and the

resonance of place, and as she sleepwalks through Paris, leading Breton in her wake, memory and desire refashion the streets: 'I don't know why it should be precisely here that my feet take me, here that I almost invariably go without specific purpose, without anything to induce me but this obscure clue: that it (?) will happen here. I cannot see, as I hurry along, what could constitute for me, even without my knowing it, a magnetic pole in either space or time.'[28] *Nadja* details a journey both governed by chance and dictated by desire, but while Paris is transformed into a place of erotic intrigue, it is given no political content.

If we are looking for the text that will bridge the playful practices of the avant-garde and the revolutionary politics of the Situationists, then this link is provided by Aragon's *Paris Peasant*. While *Nadja* is an embodiment of the city as the eternal female, *Paris Peasant*, although it acknowledges the erotic content of the streets and contains the customary visit to a brothel, also rails against the destruction of this city, whose arcades were soon to be demolished. In the same vein as Baudelaire and Benjamin, Aragon's text is a document of a city disappearing before his eyes and it was *Paris Peasant* that first drew Benjamin's attention to the significance of the arcades and to the role of walking as a cultural act, leading him to comment on the impact of the book: 'Each evening in bed I could not read more than a few words of it before my heartbeat got so strong I had to put the book down.'[29]

Aragon's account of two walks undertaken in Paris between 1924 and 1926 is unlikely to provoke heart failure in the contemporary reader, but if there is one book that may be identified as a handbook for today's breed of psychogeographer, then this is it. With its casual and seemingly unplanned combination of local history and biography, political and philosophical debate and digressive style, it reminds one of Iain Sinclair's documentary accounts of London walks in *Lights Out for the Territory*. When Aragon laments the destruction of the arcades, noting that 'The great American passion for city planning... now being applied to the task of redrawing the map of our capital in straight lines, will soon spell the doom of these human aquariums'[30], the parallels with London in the 1980s, when writers railed in a similar fashion against Thatcherite redevelopment, are unmistakeable.

'How long shall I retain this sense of the marvellous suffusing everyday existence?' muses Aragon[31] and sadly, for the Surrealists, the answer was to be, 'Not for much longer.' Breton, in particular, promised much in his *Manifestoes* but the reality was to remain stubbornly mundane and the realm of divine enchantment tantalisingly out of reach. Automatism turned out to provide rather tedious and uninspired results, and as far as walking was concerned, a lot of legwork was expended with little obvious result. The surrealist engagement with communism had a rather desultory effect on those members more used to the spirit of playful abandon from

which the movement had arisen, and in a foretaste of the problems that were to beset Debord a generation later, Breton managed to alienate almost all his former allies as surrealism collapsed under the weight of personal vendetta and infighting. *Paris Peasant*, however, remains, alongside *Nadja*, as a document to a way of life under threat. For as the ill-fated surrealist dalliance with communism was to indicate, the day of the apolitical and dispassionate stroller was at an end. What the avant-garde in general, and these books in particular, demonstrate, is the degree to which the *flâneur* can no longer stand at the wayside or retreat to his armchair but must now face up to the destruction of his city. In the aftermath of the war, the streets were radicalised as never before and revolutionary change was in the air. If the urban wanderer was to continue his aimless strolling then the very act of walking had to become subversive, a means of reclaiming the streets for the pedestrian. Psychogeography was about to be born.

Notes

[1] Rebecca Solnit, *Wanderlust*, p199
[2] Ibid, p198
[3] Edgar Allan Poe, 'The Man of the Crowd' in *The Fall of the House of Usher and Other Tales*, p139
[4] Charles Baudelaire, *The Painter of Modern Life*, p7
[5] Ibid, p9
[6] Rebecca Solnit, p200
[7] Quoted in Solnit, p197
[8] Walter Benjamin, *Charles Baudelaire*, p129

[9] Ibid, p170

[10] Ibid, p54. This passage is celebrated, but according to Solnit, apocryphal: 'No one has named an individual who took a tortoise for a walk, and all who refer to this practice use Benjamin as their source.' *Wanderlust*, p200

[11] Ibid, p54

[12] Ibid, p47

[13] Xavier de Maistre, *A Journey Around My Room*, p7

[14] Ibid, p7

[15] Joris-Karl Huysmans, *Against Nature (Á Rebours)*, p142–3

[16] Zygmunt Bauman, 'Desert Spectacular' in Keith Tester (Ed) *The Flâneur*, p138

[17] John Sturrock, *Céline: Journey to the End of the Night*, p37

[18] Louis-Ferdinand Céline, *Journey to the End of the Night*, p7

[19] Weldon Kees, 'Robinson at Home' *Collected Poems*, p136

[20] Chris Petit, *Robinson*, p34

[21] Louis Aragon, *Paris Peasant*, p14

[22] Rebecca Solnit comments: 'The love of a citizen for his city and the lust of a man for a passer-by has become one passion. And the consummation of this passion is on the streets and on foot. Walking has become sex.' *Wanderlust*, p20

[23] Roger Farr writes: 'In the psychogeographical novel, the journey is really a drift, which is to say it is open-ended, because unlike other narratives of the journey, the hero on the *dérive* is without a destination.' Farr identifies both *Nadja* and *Paris Peasant* as examples of the

psychogeographical novel, as well as Poe's short story *The Man of the Crowd* and, less obviously, Virginia Woolf's *Mrs Dalloway*. See Roger Farr, *The Chronotype of the Dérive: Towards a Generic Description of the Psychogeographical Novel*, at http://merlin.capcollege.bc.ca/english/rfarr/psychogeographical_novel.html

[24] André Breton, *Manifestoes of Surrealism*, p14

[25] Antony, Rachel & Henry, Joel (Eds) *The Lonely Planet Guide to Experimental Travel*, p19/20

[26] Roger Farr, *Chronotype of the Dérive*

[27] André Breton, *Nadja*, p 112

[28] Ibid, p32

[29] Susan Buck Morss, *The Dialectics of Seeing: Walter Benjamin and the Arcades Project,* quoted in Solnit, p206

[30] Louis Aragon, p14

[31] Ibid, p11

Guy Debord and the
Situationist International

The word psychogeography, *suggested by an illiterate Kabyle as a general term for the phenomena a few of us were investigating around the summer of 1953, is not too inappropriate.*

Guy Debord, *Introduction to a
Critique of Urban Geography* [1]

By the end of the Second World War the Surrealist movement was effectively over and the publication of Maurice Nadeau's *History of Surrealism* in 1944 provided its epitaph. Surrealism had failed to deliver on its ambitious promises to reform society and allow all to share in the apprehension of the marvellous that it had revealed. The tension between aesthetic and political impulses within the movement inevitably resulted in splits and counter-movements and it was as a response to a perceived lack of political radicalism that many of the pre-situationist movements of post-war Europe were formed. Movements as diverse and ephemeral as Cobra, the Lettrist International and the Imaginist Bauhaus formed a new avant-garde fuelled by new revolutionary sentiments, but they were hampered both by a lack of direction and, indeed, members. Acknowledging their debt

to the playful subversion of dada and surrealism, these movements continued to proclaim the need for a new society, free from the homogenising effects of capitalist development, but it was only with the emergence of the Situationist International in 1957 that a momentum for change began to appear. From 1957 until the riots of Paris in 1968, the Situationist movement, under the firm, if not tyrannical, grip of Guy Debord, produced a series of statements that defined terms such as psychogeography, the *dérive* and *détournement* for the first time (although they had been in use for some years by pre-situationist groups).

Debord, like Breton before him, was soon to display those very dictatorial tendencies that had reduced the Surrealists to an exhausting round of infighting and expulsions and, in a similar vein, he was equally disinclined to acknowledge the clear debt the Situationists owed, both to surrealism and to earlier traditions of urban exploration. However, although psychogeography plays a significant part in Debord's schema, particularly in its early years, it would be quite misleading to somehow equate it with the Situationist movement as a whole. Psychogeography is merely one tool amongst many and one whose role was to become more oblique, as situationism moved away from the subversive practices of its unacknowledged forebears and towards the revolutionary politics with which it has since become associated. Indeed, psychogeography barely merits a mention in the two major theoretical statements of situationism, Debord's *The Society of the Spectacle* and Raoul

Vaneigem's *The Revolution of Everyday Life*.

Situationism continued to place Paris at the heart of a tradition of urban wandering that led back to the arcades of the nineteenth-century city and this position was not coincidental, as Rebecca Solnit has indicated: 'Paris is the great city of walkers. And it is the great city of revolution.'[2] As a consequence, it can be of little surprise that Paris has provided us with that other great theoretician of urban wandering, Michel de Certeau, and it is his *The Practice of Everyday Life* that provides a useful postscript to situationist psychogeography, as well as moving the focus of the debate across the Atlantic to New York.

Before discussing these movements and the evolution of psychogeography within them, it should be noted that despite the unquestioned association between psychogeography and post-war Paris, there is another claimant to the founding of the discipline. The more obscure figure of academic William G. Niederland is also credited with pioneering psychogeography as a methodology – through a series of studies on the nature of river symbolism in the 1950s.[3] It is safe to assume, however, that neither Niederland nor Debord was aware of the other's work.

The Pre-Situationist Movements[4]

Amidst a mass of statements and journals, the clearest and best known formulation of pre-situationist thinking is to be found in Ivan Chtcheglov's *Formulary for a New Urbanism*, written in 1953 but not published until 1958. The

unpronounceable Chtcheglov was in fact Gilles Ivain, a 19-year-old member of the Lettrist International (1952–7) who was later to be incarcerated in an asylum. His *Formulary* certainly seems to display ample evidence of his oncoming mental illness and, although it does not mention psychogeography, it does provide a familiar outline of how the city must be rebuilt upon new principles that replace our mundane and sterile experiences with a magical awareness of the wonders that surround us. 'We are bored in the city, there is no longer any Temple of the Sun'[5] claims Chtcheglov, as he proceeds to outline a new method of apprehending our environment:

> All cities are geological; you cannot take three steps without encountering ghosts bearing all the prestige of their legends. We move within a closed landscape whose landmarks constantly draw us toward the past. Certain *shifting* angles, certain *receding* perspectives, allow us to glimpse original conceptions of space, but this vision remains fragmentary. It must be sought in the magical locales of fairy tales and surrealist writings: castles, endless walls, little forgotten bars, mammoth caverns, casino mirrors.[6]

'A mental disease has swept the planet: banalisation,'[7] he continues, and Chtcheglov prescribes a cure for this malaise by envisaging a new urban environment in which architecture reflects an emotional engagement with its inhabitants, offering the passion and desire to overcome the hypnotising effects of the modern commercial world. Needless to say, the details for establishing such an

environment are absent, and as Chtcheglov continues with the proclamation that 'Everyone will live in his own personal "cathedral", so to speak. There will be rooms more conducive to dreams than any drug, and houses where one cannot help but love,'[8] one is forced to question how one might implement such a scheme.

Unabashed, Chtcheglov advances, describing entire cities, their districts corresponding to 'the whole spectrum of diverse feelings that one encounters *by chance* in everyday life. Bizarre Quarter – Happy Quarter (specially reserved for habitation) – Noble and Tragic Quarter (for good children) – Historical Quarter (museums, schools) – Useful Quarter (hospital, tool shops) – Sinister Quarter etc.'[9]

The *Formulary* concludes with a call for a 'CONTINUOUS DÉRIVE'[10], that ambient drifting through the urban environment that was to later be defined by Debord and which is the predominant technique of psychogeography. The Lettrist International (1952–7) was itself a product of the earlier Lettrist Group formed in 1948 and the *Formulary* is the first significant monument to a movement that Stewart Home has described as 'undoubtedly ludicrous'.[11] Although it is true that the practical impact of this and similarly negligible outfits such as COBRA and the Imaginist Bauhaus was zero, the Lettrist International plays an unexpectedly important role in the emergence of psychogeography in its situationist format. For it is in the journal *Potlatch* or, to give it its full title, *The Bulletin of Information of the French Group of the Lettrist International,* that psychogeography first appears in print.

Potlatch #1 appeared on 22 June 1954 and the 50 copies in the first print run were circulated as gifts. Rehearsing concepts here that were to be given coherent definition by Debord and the Situationists some four years later, *Potlatch* nevertheless provides some characteristically bizarre psychogeographical experiments, the first being the 'Psychogeographical Game of the Week' in *Potlatch #1*:

> Depending on what you are after, choose an area, a more or less populous city, a more or less lively street. Build a house. Furnish it. Make the most of its decoration and surroundings. Choose the season and the time. Gather together the right people, the best records and drinks. Lighting and conversation must, of course, be appropriate, along with the weather and your memories. If your calculations are correct, you should find the outcome satisfying. (Please inform the editors of the results.)[12]

This weakly humorous and unattributed student jape is a rather inauspicious beginning for psychogeography's textual history and it was soon to be followed in equally uninspired fashion by Debord's 'Exercise in Psychogeography' in *Potlatch #2*:

> Piranesi is psycho-geographical in the stairway.

> Claude Lorrain is psycho-geographical in the juxtaposition of a palace neighbourhood and the sea.

> The postman Cheval is psycho-geographical in architecture.

Arthur Cravan is psycho-geographical in hurried drifting.

Jacques Vache is psycho-geographical in dress.

Louis II of Bavaria is psycho-geographical in royalty.

Jack the Ripper is probably psycho-geographical in love.

Saint-Just is a bit psycho-geographical in politics. (Terror is disorienting.)

Andre Breton is naively psycho-geographical in encounters.

Madeleine Reineri is psycho-geographical in suicide. (See *Howls in Favor of de Sade*.)

Along with Pierre Mabille in gathering together marvels, Evariste Gaullois in mathematics, Edgar Allan Poe in landscape, and Villiers de l'Isle Adam in agony.[13]

It is clear that those wishing to find a cogent expression of psychogeography's origins, purpose or definition will be disappointed by the meagre offerings presented in *Potlatch*, and just to emphasise the feeble level of adolescent humour to be found here, *Potlatch* #9 (thankfully this journal was mercifully short-lived and ran to only 27 issues) provides this unhelpful insight entitled 'Psychogeography and Politics' and credited to Nicolas Gogol: 'It has come to my attention that China and Spain are one and the same land and that it is only out of ignorance that they are considered to be separate states.'[14]

Potlatch harks back to the playful practices of the Dadaists and displays little concern for the theoretical rigours that Debord was soon to enforce. These pre-situationist movements largely confined themselves to formulating impressive titles for themselves and continuing an ongoing process of mergers and splits in a bizarre parody of the corporate institutions to whose overthrow they were dedicated. Stewart Home comments that these early psychogeographical exercises 'did not produce the kind of data from which *serious scientific research* could progress,'[15] but Guy Debord, discarding these whimsical excesses, was soon attempting to remedy this. It was his *Introduction to a Critique of Urban Geography*, written in September 1955 and later published in the Belgian journal *Les Lèvres Nues*, that was to display this more rigorous approach and with it the first, and oft-repeated, definition of psychogeography:

The word *psychogeography*, suggested by an illiterate Kabyle as a general term for the phenomena a few of us were investigating around the summer of 1953, is not too inappropriate. It does not contradict the materialist perspective of the conditioning of life and thought by objective nature. Geography, for example, deals with the determinant action of general natural forces, such as soil composition or climatic conditions, on the economic structures of a society, and thus on the corresponding conception that such a society can have of the world. *Psychogeography* could set for itself the study of the precise laws and specific effects of the geographical environment, consciously organized or not, on the emotions and

behaviour of individuals. The adjective *psychogeographical*, retaining a rather pleasing vagueness, can thus be applied to the findings arrived at by this type of investigation, to their influence on human feelings, and even more generally to any situation or conduct that seems to reflect the same spirit of discovery.[16]

So, here we have it – an attempt to define what psychogeography is all about. Debord gives himself a useful get-out clause by noting the 'pleasing vagueness' of the term and it has been exactly this vagueness that has allowed so many writers and movements to identify themselves and their work under this label. Psychogeography becomes for Debord the point where psychology and geography collide. Gone are the romantic notions of an artistic practice; here we have an experiment to be conducted under scientific conditions and whose results are to be rigorously analysed. The emotional and behavioural impact of urban space upon individual consciousness is to be carefully monitored and recorded, its results used to promote the construction of a new urban environment that both reflects and facilitates the desires of the inhabitants of this future city, the transformation of which is to be conducted by those people skilled in psychogeographical techniques.

Debord continues in much the same vein as Chtcheglov, with a description of how the city may be separated into zones corresponding to the emotional responses they evoke:

The sudden change of ambience in the street within the space of a few meters; the evident division of a city into

zones of distinct psychic atmospheres; the path of least resistance which is automatically followed in aimless strolls (and which has no relation to the physical contour of the ground); the appealing or repelling character of certain places – all this seems to be neglected. In any case it is never envisaged as depending on causes that can be uncovered by careful analysis and turned to account. People are quite aware that some neighbourhoods are sad and others pleasant. But they generally simply assume that elegant streets cause a feeling of satisfaction and that poor streets are depressing, and let it go at that. In fact, the variety of possible combinations of ambiances, analogous to the blending of pure chemicals in an infinite number of mixtures, gives rise to feelings as differentiated and complex as any other form of spectacle can evoke.[17]

Psychogeography is, according to Debord, a pure science, and like the skilled chemist, the psychogeographer is able both to identify and to distil the varied ambiances of the urban environment. Emotional zones that cannot be determined simply by architectural or economic conditions must be determined by following the aimless stroll (*dérive*), the results of which may then form the basis of a new cartography characterised by a complete disregard for the traditional and habitual practices of the tourist:

The production of psychogeographical maps, or even the introduction of alterations such as more or less arbitrarily transposing maps of two different regions, can contribute to clarifying certain wanderings that express not subordination to randomness but complete *insubordination*

to habitual influences... A friend recently told me that he had just wondered through the Harz region of Germany while blindly following the directions of a map of London. This sort of game is obviously only a mediocre beginning in comparison to the complete construction of architecture and urbanism that will someday be within the power of everyone.[18]

Debord is himself credited with the production of such a map, published in 1957 under the title *The Naked City*, and today this map adorns the covers of many of the books exploring situationism, dividing Paris into nineteen sections, cut up and seemingly randomly dispersed. The users of such a map are able to choose their own direction following a series of arrows which link the various parts of the city according to the emotional context the reader wishes to ascribe to them. There is of course no 'correct' reading for such a map.[19]

Such practices, with their clear roots in the tradition of surrealist collage, remind one of their disavowed avant-garde heritage but, as the pre-situationist movements gave way to situationism proper, this heritage was increasingly forgotten or ignored and the spirit of playful creativity was soon to be transformed into one of more overt political protest. In July 1957 this pre-situationist phase of largely unproductive navel-gazing finally came to an end, as the Situationist International was founded at a 'conference' in Cosio d'Arroscia in Italy. What was presented in typically grandiloquent style, as the merger of the Lettrist International and Asger Jorn's International Movement for

an Imaginist Bauhaus, was in reality eight delegates 'in a state of semi-drunkenness'[20] meeting in a remote bar and this pub lunch-cum-party conference was bolstered by the attendance of the London Psychogeograhical Committee in the form of its single and only known member, Ralph Rumney. It was from these humble origins that the Situationist International was to emerge.

The Situationist International (1957–1972)

From the outset, the Situationist International sought to distance itself from the primarily artistic preoccupations of the Lettrists in favour of a revolutionary political agenda which was in large part dependent upon the Marxist philosophy that dominated French intellectual fashion in the 1950s. Hence, what had been a playful avant-garde movement with a clear debt to the Surrealists was gradually reworked to become a radical political organisation keen to overthrow and replace what it saw as the predominantly bourgeois nature of western society.

To this end, a number of practices and techniques were subordinated, amongst them psychogeography, the *dérive* and *détournement,* and under the editorship of Guy Debord, the new *Internationale Situationniste* displayed a practical tone recognisably at odds with its lettrist predecessors. While *Potlatch* tended to preach to the converted, offering little more than an in-house journal that took as given its readership's understanding of its terminology and sympathy with its ideas, *International Situationiste* sought a

wider audience and was quick to offer a (not altogether helpful) glossary of its terminology:[21]

Situationist Having to do with the theory or practical activity of constructing situations. A member of the Situationist International.

Situationism A meaningless term improperly derived from the above. There is no such thing as situationism, which would mean a doctrine of interpretation of existing facts. The notion of situationism is obviously devised by anti-situationists.

Psychogeography The study of the specific effects of the geographical environment, consciously organized or not, on the emotions and behaviour of individuals.

Psychogeographical Relating to psychogeography. That which manifests the geographical environment's direct emotional effects.

Psychogeographer One who explores and reports on psychogeographical phenomena.

Dérive A mode of experimental behaviour linked to the conditions of urban society: a technique of transient passage through varied ambiances. Also used to designate a specific period of continuous deriving.

Unitary Urbanism The theory of the combined use of arts and techniques for the integral construction of a milieu in dynamic relation with the experiments in behavior.

Détournement Short for: détournement of pre-existing aesthetic elements. The integration of present or past artistic production into a superior construction of a milieu. In this sense there can be no situationist painting or music, but only a situationist use of these means. In a more primitive sense, détournement within the old cultural spheres is a method of propaganda, a method which testifies to the wearing out and loss of importance of those spheres.

These definitions fit together like a set of Russian dolls: on the outside is situationism and beneath it, its agenda to transform urban life – unitary urbanism. This, in turn, reveals its methodology – psychogeography – and this itself gives way to the twofold techniques at its disposal – the *dérive* and *détournement*. These last two concepts are the subject of more detailed analysis by Debord in his *Methods of Détournement* and *Theory of the Dérive*. The former, first published in *Les Lèvres Nues* #8 in 1956 and co-authored by Gil J Wolman, uses the example of the French nineteenth-century poet and self-styled Comte de Lautréamont, Isidore Ducasse, whose poem *Les Chants de Maldoror* was highly influential on the Surrealists. Here, Lautréamont espouses the merits of plagiarism, writing: 'Plagiarism is necessary. It is implied in the idea of progress. It clasps an author's sentence tight, uses his expressions, eliminates a

false idea, replaces it with the right idea.'[22] Plagiarism is one of the methods by which *détournement* seeks to liberate a word, statement, image or event from its intended usage and to subvert its meaning. 'The theft of aesthetic artefacts from their own contexts and their diversion into contexts of one's own device,' as Stewart Home has defined it.[23] Recalling the juxtapositions of the Surrealists' found-object, similarly divorced from its original context, *détournement* creates new and unexpected meanings by hijacking and disrupting the original. Stewart Home's proclamation that 'There is a spectre haunting Europe, the spectre of psychogeography.' neatly demonstrates *détournement* in action by lifting Marx's famous slogan from his *Communist Manifesto* and making a simple alteration.[24]

Debord describes two categories of *détournement*, the minor and the deceptive:

> Minor *détournement* is the *détournement* of an element which has no importance in itself and which thus draws all its meaning from the new context in which it has been placed. For example, a press clipping, a neutral phrase, a commonplace photograph.
>
> Deceptive *détournement*, also termed premonitory proposition détournement, is in contrast the *détournement* of an intrinsically significant element, which derives a different scope from the new context. A slogan of Saint-Just, for example, or a sequence of Eisenstein.[25]

'Ultimately,' writes Debord, 'any sign or word is susceptible to being converted into something else, even

into its opposite.'[26] And *détournement* demonstrates how an avant-garde artistic practice can be turned to political ends, providing a simple tool that subverts one's opponent's message while promoting one's own.

Also written in 1956, but first published in the *Internationale Situationniste* #2 in December 1958, Guy Debord's *Theory of the Dérive* outlines the second tool at the psychogeographer's disposal. Described as 'a technique of transient passage through varied ambiances,' the *dérive* involves 'playful-constructive behavior and awareness of psychogeographical effects; which completely distinguishes it from the classical notions of the journey and the stroll.'[27] This statement is a highly contentious one, for it seems hard to think of the *dérive* in terms other than of those strolls undertaken by the Surrealists a generation earlier. Yet, on closer inspection, although both appear to involve an element of chance and lack a pre-ordained direction, the *dérive* does not demonstrate the pure submission to unconscious desire that characterised the surrealist wanderings or the journeys of the strolling *flâneur*. The *dérive* may lack a clear destination but it is not without purpose. On the contrary, the *dériveur* is conducting a psychogeographical investigation and is expected to return home having noted the ways in which the areas traversed resonate with particular moods and ambiences. The results of this fieldwork form the basis for the situationist refashioning of the city. In fact, it has been claimed that, far from being the aimless empty-headed drifting of the casual stroller, Debord's principle is nearer to a military strategy and has its roots not in earlier avant-garde

experimentation but in military tactics where drifting is defined as 'a calculated action determined by the absence of a proper locus.' In this light, the *dérive* becomes a strategic device for reconnoitring the city, 'a reconnaissance for the day when the city would be seized for real.'[28]

The *dérive* takes the wanderer out of the realm of the disinterested spectator or artistic practitioner and places him in a subversive position as a revolutionary following a political agenda. The *dériveur* is the foot soldier in a situationist militia, an advance guard sent out to observe enemy territory, for as Robert MacFarlane has noted, 'Mapping has always marched in the vanguard of the imperial project, for to map a country is to know it strategically as well as geographically, and therefore to gain logistical power over it.'[29] Keen to distinguish his concept from the 'dismal failure' of surrealist strolling, Debord plays down the element of chance, claiming that, 'The element of chance is less determinant than one might think: from the *dérive* point of view cities have a psychogeographical relief, with constant currents, fixed points and vortexes which strongly discourage entry into or exit from certain zones.'[30] It is the role of the psychogeographer both to attune himself to these currents and to overcome them if they are to be reshaped and redirected:

> Progress is nothing other than breaking through a field where chance holds sway by creating new conditions more favourable to our purposes. We can say, then, that the randomness of the *dérive* is fundamentally different from

that of the stroll, but also that the first psychogeographical attractions discovered run the risk of fixating the dériving individual or group around new habitual axes, to which they will constantly be drawn back.[31]

Debord balances theoretical concerns with more practical information, suggesting that the *dérive* should be conducted in small groups of two or three people and noting that its average duration is a single day, although acknowledging that one sequence of *dérives* lasted for around two months. Storms and other types of precipitation are apparently favourable but prolonged rains can render them almost impossible. The use of taxis is not forbidden but can alter the nature of the *dérive*. In conclusion, Debord writes:

> The lessons drawn from the *dérive* permit the drawing up of the first surveys of the psychogeographical articulations of the modern city. Beyond the discovery of unities of ambiance, of their main components and their spatial localization, one comes to perceive their principal axes of passage, their exits and their defences. One arrives at the central hypothesis of the existence of psychogeographical pivotal points.[32]

So, the stage has been set. Debord has provided us with our theoretical underpinning as well as furnishing us with practical advice. It is 1958, Paris is ripe for revolutionary change and armed with *détournement* and the *dérive*, we are sent into the field. It is at this point, however, that one cannot help but notice that while the theoretical and

instructive elements of psychogeography are manifest, the actual results of all these experiments are strangely absent. Trawling through the extensive literature on psycho-geography and situationism, one is hard pressed to find any concrete evidence of clear instances of psychogeographical activity. Rather dismissively, one commentator has observed, 'Perhaps not surprisingly, the Situationists didn't do much in the way of travel – they were too busy talking, fighting, writing manifestos and being expelled to get much travelling done.'[33] Can she be right?

The *Internationale Situationniste* #2 carries alongside Debord's *Theory of the Dérive,* a piece entitled *Attempt at a Psychogeographical Description of Les Halles* credited to Abdelhafid Khatib. This is one of the very few extant examples of actual psychogeographical research by the Situationists. Khatib mentions Asger Jorn's description of psychogeography as 'the science fiction of urbanism'[34] but the outline that Khatib provides owes less to science fiction and more to a particularly unreadable form of travel guide. Taking the Les Halles quarter of Paris as his starting point, Khatib provides a series of increasingly mundane observ-ations: 'A population of down-and-outs holds sway around the Square des Innocents' we are told, 'The whole area is depressing...' By contrast, the area around the Rue de Rivoli is 'by night hard-working and lively.' Towards the north of Les Halles one finds 'an intense activity in food retailing and an important administrative centre.'[35] And so it continues.

To be fair to Khatib, an Algerian national, he was unable to complete his study of Les Halles due to repeated

harassment from the police. North Africans were at this time subject to curfew and after twice being arrested and spending the night in a cell, he was understandably reluctant to continue. He resigned from the Situationist International in 1960. This example and that of Ralph Rumney's ill-starred attempt to provide a psychogeographical account of Venice – he was expelled from the organisation by Guy Debord for failing to submit his report on time – not only demonstrate the hapless nature of much of this so-called research but also, and more importantly, question the real value of psychogeography as a practical tool.

It seems that by 1960, Debord and his colleagues were asking themselves the same question and following the brief flowering of psychogeographical theorising in the 1950s, in the subsequent decade these ideas and their practical application are conspicuous by their absence.

By 1962 the Situationist movement had split, as tensions between artistic and political priorities resurfaced once again. The Second Situationist International was now separated from the Specto-Situationist International, the latter group, under Debord and Vaneigem, now free to pursue an increasingly overt political agenda. Thanks to the translation of their works into English, situationism is today much better known for its emphasis on revolutionary politics than for its cultural component. Considered solely on its merits as a practical tool at the vanguard of a revolutionary movement, psychogeography must be considered an abject failure. The meagre results of prolonged theorising reveal such a paucity of useful

material that it is barely surprising that psychogeography fell from favour. In this respect, as in so many others, the fate of psychogeography resembles that of automatism in the Surrealist movement, where a prominent theoretical position at the outset was quickly followed by a realisation of its obvious limitations and its quiet demotion.

Looking back upon his former friendship with Debord (a period culminating in his inevitable expulsion from the Situationist movement), Scottish beat writer, pornographer and junkie, Alexander Trocchi wrote: 'I remember long, wonderful psychogeographical walks in London with Guy... He took me to places in London I didn't know, that he didn't know, that he sensed that I'd never have been to if it hadn't been with him. He was a man who could discover a city.'[36] This search for de Quincey's 'Northwest Passage', a psychogeographical metaphor for that concealed entrance to the magical realm which had been at the forefront of early situationist ideas, was soon to be forgotten as Debord, in the years following the 1962 split, became increasingly preoccupied with a Marxist revisionism that had little time for the unfettered romanticism that Trocchi had so fondly recalled. But ultimately Debord came to recognise the essentially personal nature of the relationship between the individual and the city, sensing that this subjective realm was always going to remain at odds with the objective mechanisms of the psychogeographical methodology that sought to expose it. 'The secrets of the city are, at a certain level, decipherable,' wrote Debord, 'But the personal meaning they have for us is incommunicable.'[37]

Resisting the subjective and mysterious currents that the *dérive* promoted, Debord became increasingly dogmatic in his insistence upon a rigorous examination of the spectacular society – a society whose seductive surface belied the repressive realities of capitalist consumption. Debord's *Society of the Spectacle* was published in 1967 and its allusive and often ambiguous series of *aperçus* proved tailor-made in providing the slogans that would adorn Paris during the uprising the following year. Like the other iconic situationist text, Raoul Vaneigem's *The Revolution of Everyday Life*, Debord's work makes no mention of psychogeography, preferring instead to tackle the more broadly philosophical themes of time, history and society. 'We have a world of pleasures to win, and nothing to lose but boredom,' proclaims Vaneigem in a *détournement* of Marx's famous revolutionary dictum, and Debord is equally explicit in his emphasis upon the sheer banality of contemporary society: 'Behind the glitter of spectacular distractions, a tendency toward *banalisation* dominates modern society the world over, even where the more advanced forms of commodity consumption have seemingly multiplied the variety of roles and objects to choose from.'[38]

The essential emptiness of modern life is obscured behind an elaborate and spectacular array of commodities and our immersion in this world of rampant consumerism leaves us disconnected from the history and community that might give our lives meaning. Amidst this relentless and regimented monotony, street life has been suppressed and that same hostility to the pedestrian that drove the

flâneur from the streets of nineteenth-century Paris continues unabated today. The urban wanderer has been subordinated to the 'dictatorship of the automobile'[39] as a new urban landscape emerges, a non-place dominated by technology and advertising whose endless reflective surfaces are devoid of individuality. This is the future that Debord is challenging, one that was soon to find fictional representation in the work of JG Ballard and which psychogeography had ambitiously hoped to transform.

Of course, the Situationists' moment came and passed and the ultimate failure of 1968 was followed by the movement's dissolution in 1972. But, while situationist psychogeography had proved unable to live up to its ambitious promises, the movement was not to provide the last word in the theorising of urban walking. Although emerging from a quite different tradition, Michel de Certeau's comments on walking the city in his *The Practice of Everyday Life* offer us both a new sense of the possibilities afforded to the pedestrian and a new city within which to undertake it – New York.

Walking the City with Michel de Certeau

De Certeau may dispense with the stifling Marxist rhetoric of Debord and Vaneigem but he outstrips them both with the sheer opacity of his prose. Upholding the finest traditions of contemporary French theory, de Certeau's comments display an utter disregard for clarity, instead favouring an approach that ensures his work a place within

the burgeoning ranks of the unread. Written in 1984, the title of de Certeau's *The Practice of Everyday Life*, invokes both Vaneigem's *Revolution of Everyday Life* and Henri Lefebvre's *Critique of Everyday Life* as accounts that seek to understand and theorise the practices of the 'common man' through an analysis of the patterns of his everyday existence. Thus de Certeau provides an epigraph to his work dedicated, 'To the ordinary man. To the common hero, an ubiquitous character, walking in countless thousands on the streets.'[40] De Certeau's highly abstract take on those everyday practices that characterise modern life, from speaking and reading to walking and cooking, displays a curious logic that reveals, through a semiotic and poetic analysis of these practices, patterns and strategies common to each of them. In this way he attempts to illustrate the hidden structure of modern urban life that governs the relationship between a city and its inhabitants.

It is de Certeau's comments under the heading 'Walking in the City' that interest us here. Taking the example of New York, he contrasts this city with its Old World, European counterparts through the fact that it 'has never learned the art of growing old by playing on all its pasts.'[41] Unlike London and Paris, New York reflects a spirit of constant renewal and this sense of a perpetual present is characterised by two opposing perspectives on the city: that of *voyeur* and *walker*. According to de Certeau, New York is the apotheosis of the modern city in as far as the division between the walker at street-level and the voyeur inhabiting the summit of the skyscrapers above is at its

most stark. 'The ordinary practitioners of the city live "down below", below the thresholds at which visibility begins. They walk – an elementary form of this experience of the city: they are walkers.'[42] But looking down upon them from up-above, with a panoptical god-like view, are the voyeurs who experience the city as a vast totality far removed from any individual perspective: 'To be lifted to the summit of the World Trade Center is to be lifted out of the city's grasp. One's body is no longer clasped by the streets... when one goes up there, he leaves behind the mass that carries off and mixes up in itself any identity of authors or spectators... His elevation transfigures him into a voyeur. It puts him at a distance.'[43]

This is the distinction that governs modern urban life, that between walker and voyeur, and it is one which emphasises the democratic importance of the street-level perspective to be gained from walking the city and reconnecting with individual life. This is the return to the street promoted by the Situationists who railed against the systematic and totalising perspective of the governing authorities. In the light of this distinction it is clear how the simple act of walking can take on a subversive hue, abolishing the distancing and voyeuristic perspective of those who view the city from above. This dual perspective is built-in within the structure of the modern city and is what psychogeography seeks to overturn, restoring the primacy of the street. For the totalising gaze of the voyeur sees the city as a homogenous whole, an anonymous urban space that sees no place for individual or separate identities

and which erases or suppresses the personal and the local: 'Stories are becoming private and sink into the secluded places in neighbourhoods, families, or individuals, while the rumours propagated by the media cover everything and, gathered under the figure of the City, the masterword of an anonymous law, the substitute for all proper names, they wipe out or combat any superstitions guilty of still resisting the figure.'[44] Only by resisting this overview can the individual re-establish the emotional engagement with his surroundings that psychogeography promotes. For 'their story begins on ground level, with footsteps,' writes de Certeau, and it is here, not up above, that the history of the city is written.

However, de Certeau also exposes the contradiction between the objective methods of recording these journeys across the city and the subjective nature of the individual histories they reflect. Walking can easily be monitored and mapped as the millions of individual journeys criss-crossing the city leave a trace that can be plotted. But this trace can, in itself, never capture the personal histories that underlie them. Thus, as the Situationists found to their cost, a rigorous sociological or geographical attempt to map the city and to categorise regions according to the results of such surveys simply reveals the contradiction between the objectivity of the method and the subjectivity of that which is to be catalogued. A map can never accurately capture the lives of those individuals whose journeys it sets out to trace, for in the process individuality is inevitably flattened out and

reduced to points on a chart.

'Every story is a travel story, a spatial practice,'[45] writes de Certeau and any theoretical system that tries to measure this story will inevitably exclude as much as it reveals. In this respect, de Certeau's theory of walking highlights the limitations of all systematic theoretical systems, psychogeography included, in accurately capturing the relationship between the city and the individual. These frameworks cut across the city, separating communities with artificial categorisations, and disrupting what is essentially an ongoing narrative, a story that has a cast of millions and whose plot is unknown. In this sense, the objective and programmatic approach of the sociologists and geographers threatens to obscure that which they seek to preserve, rendering them less able to assess urban life accurately than the historians and novelists that have preceded them in this account.

'Beneath the fabricating and universal writing of technology, opaque and stubborn places remain,'[46] claims de Certeau, but in our modern technological landscape, increasingly homogenous and regulated, dominated by surveillance and hostile to the pedestrian, it is now the novelist and the poet, not the theorist, who are uncovering and celebrating these overlooked and forgotten corners of the city. Today, as we assess the contemporary role of psychogeography and return to London, where we began, it will be to turn to those writers, poets and filmmakers who have kept alive the memory of these neglected aspects of the city.

Notes

1 Guy Debord, 'Introduction to a Critique of Urban Geography', Knabb, p5

2 Rebecca Solnit, p218

3 Vamik D Volkan writes: 'Psychogeography as an area of study was founded during the 1950s by William G Niederland, M.D., in a series of pioneering studies on the nature of river symbolism...' See Howard F Stein & William G Niederland (Eds) *Maps from the Mind: Readings in Psychogeography*, pxxix

4 Those wishing to acquire a detailed understanding of the short-lived and often invisible series of movements and counter movements that characterise the pre-situationist decade leading up to 1957 should consult Stewart Home's exhaustive *The Assault on Culture: Utopian Currents from Lettrisme to Class War*.

5 Ken Knabb, p1

6 Ibid, p1–2

7 Ibid, p2

8 Ibid, p3

9 Ibid, p4

10 Ibid, p4

11 Stewart Home, *The Assault on Culture*, p22

12 From *Potlatch* #1 and quoted in Andreotti & Costa (Eds) *Theory of the Dérive and Other Situationist Writings on the City*, p42

13 Ibid, p42

14 Ibid, p48

15 Stewart Home, *Assault on Culture*, p19

16 Guy Debord, 'Introduction to a Critique of Urban Geography', Knabb, p5

17 Ibid, p6–7

18 Ibid, p7

19 For a detailed discussion of Debord's map and its relationship to situationism, see Tom McDonough, 'The Naked City' in Tom McDonough (Ed) *Guy Debord and the Situationist International: Texts & Documents*, p241–265

20 Simon Sadler, *The Situationist City*, p4

21 From *Internationale Situationniste #1*, Knabb, p45

22 Comte de Lautréamont, *Maldoror and Poems*, p274, quoted in Simon Ford, *The Situationist International: A User's Guide*, p37

23 Stewart Home, *Assault on Culture*, p168

24 Stewart Home, *Mind Invaders*, p136. Phil Baker also uses this example to illustrate *détournement* in his 'Secret City: Psychogeography and the End of London', p327

25 Guy Debord & Gil J Wolman, 'Methods of Détournement', Knabb, p10

26 Ibid, p13

27 Guy Debord, 'Theory of the Dérive', Knabb, p50

28 Simon Sadler, p81

29 Robert MacFarlane, *Mountains of the Mind*, p186. Simon Sadler echoes MacFarlane, commenting: 'Like the imperialist powers that they officially opposed, it was as if the Situationists felt that the exploration of alien quarters (of the city rather than the globe) would advance civilisation.' Sadler, p81

[30] Guy Debord, 'Theory of the Dérive', Knabb, p50

[31] Ibid, p51

[32] Ibid, p53

[33] Antony & Henry (Eds) *Lonely Planet Guide to Experimental Travel*, p 22

[34] Abdelhafid Khatib, 'Attempt at a Psychogeographical Description of Les Halles', Andreotti & Costa, p72

[35] Ibid, p 73–77

[36] Greil Marcus, *Lipstick Traces*, p385

[37] Simon Sadler, p80

[38] Guy Debord, *Society of the Spectacle*, p28

[39] Ibid, p97

[40] Michel de Certeau, *The Practice of Everyday Life,* epigraph

[41] Ibid, p91

[42] Ibid, p93

[43] Ibid, p92

[44] Ibid, p108

[45] Ibid, p115

[46] Ibid, p201

Psychogeography Today

I've taken to long-distance walking as a means of dissolving the mechanised matrix which compresses the space-time continuum, and decouples humans from physical geography.

Will Self, quoted in *Private Eye: Mediaballs 2005.*[1]

Much has been written about psychogeography in recent years, perhaps too much. We have moved from the samizdat publications of the 1960s to Will Self's eponymous column in the *Independent*, from the dandified strollers in the Parisian arcades to Iain Sinclair's trek around the M25. What has motivated this reinvention of psychogeography and how can we account for its new-found popularity?

In many ways, psychogeography today remains alert to the increasing banalisation of our urban environment that preoccupied the Situationists, and it continues to provide a political response to the perceived failures of urban governance. And, just as the precursors to psycho-geography discussed in the opening chapter form a literary tradition based in London, so too does the current revival of psychogeography manifest itself in a primarily literary form with London once again at its centre.

Of course, the playful, plagiaristic and political activities of the Situationists and their avant-garde forebears continue to be expressed through psychogeographical groups and organisations across the globe, but these groups cannot account for the mainstream acceptance that psychogeography now holds. We must return to the fictional London from where we began.

Just as William Blake has been identified as the 'Godfather of Psychogeography,' so too can we locate a similarly totemic figure in the contemporary city. For as the Situationist movement was drawing to a close, the Seer of Shepperton, JG Ballard, was producing a series of highly experimental and controversial texts depicting the urban hinterlands of motorways and retail parks that encircle our modern cities. Ballard has written at length about the 'Death of Affect', the loss of emotional engagement with our surroundings, and novels such as *Crash* and *High-Rise* offer accounts of the unexpected and bizarre forms of behaviour our new technological landscapes can provoke. Indeed, if psychogeography is to be understood as the behavioural impact of urban space, then Ballard's work displays its most extreme edge.

Alongside Ballard, but mining a vertical seam through the city's past, Iain Sinclair is the figure most closely associated with psychogeography today. Sinclair, like Ballard before him, has been keen to expose those obscure places that lie at the margins, but he has also traversed the centre and his series of walks across the city immediately place him within earlier traditions of urban wandering. But

it is his *Lud Heat*, with its proposed alignment of Hawksmoor's London churches, that has been the key text in the neo-psychogeographical canon. Sinclair pays no allegiance to situationist theory, instead invoking the theory of ley lines proposed by Alfred Watkins and reviving the occult concerns of earlier London visionaries such as Robert Louis Stevenson and Arthur Machen. In addition, Sinclair re-establishes the figure of the *flâneur*, updating the Parisian stroller for the rigours of the London street. The occult symbolism and sense of tradition espoused by Sinclair is echoed by Peter Ackroyd who explicitly invokes the visionary traditions of the nineteenth century in his writing. Ackroyd has been described, not altogether helpfully, as a 'historico-mystical psychogeographer'[2] and through his recognition of cyclical currents unfolding across history, Ackroyd's vision of the city also owes less to the rigorous approach of the Situationists than it does to a conservative sense of national identity and a belief in the enduring power of the city. If, in Ackroyd's work, psychogeography has once again been stretched beyond the imaginings of Debord and has come to resemble little more than local history, corrupted by an unwanted mystical element, the work of Stewart Home goes some way to reaffirming its theoretical authenticity and spirit of political radicalism. As the key figure in the London Psychogeographical Association, reconvened between 1992 and 1997, Home has produced a steady output of pamphlets and novels as well as performing a series of avant-garde activities, reintroducing the provocative spirit

of situationism and its predecessors. Home's peculiar brand of theoretically alert, sex and violence fuelled parodies combine the plagiaristic tendencies of the avant-garde with a home-grown political radicalism and Sinclair's sense of London's past.

Finally, in a move from text to film, the circle is completed by Patrick Keiller, who, in his films *London* and *Robinson in Space*, marks the return of Robinson and with him the figure of Defoe with whom this survey began. In these two films, Keiller provides a psychogeographical meditation on London and the country as a whole, combining a political response to Thatcherism with an inquiry into the literary history of the city and a final word on the fate of the *flâneur*.

Of course, the writers and filmmakers discussed here by no means constitute an exhaustive account of psychogeographical ideas and their practitioners, but between them they document the evolutionary process psychogeography is currently undertaking, as it outgrows its theoretical confines to re-engage with earlier traditions and to branch off in new and unexpected directions.

JG Ballard and the Death of Affect

The dictatorship of the automobile, pilot-product of the first phase of commodity abundance, has been stamped into the environment with the domination of the freeway, which dislocates old urban centres and requires an ever-larger dispersion.

Guy Debord, *The Society of the Spectacle.*[3]

While Debord recognised the dominance of the automobile and its corollary in the demise of the pedestrian and sought the revolutionary uprising that might reverse this trend, JG Ballard has presented a much more ambiguous attitude towards this new landscape. Debord saw the encroachment of the car upon the traditional domain of the stroller as a political issue but Ballard has interpreted the car in a quite different light, viewing it as a symbol of individual freedom. In this way, rather than simply encapsulating the boredom of everyday life, the car becomes the means by which we can transcend the banality of our surroundings, the car crash becoming for the protagonist of Ballard's most famous work, 'the only real experience I had been through for years.'[4]

In his introduction to the 1995 edition of *Crash,* Ballard writes: 'Needless to say, the ultimate role of *Crash* is cautionary, a warning against that brutal, erotic and overlit realm that beckons more and more persuasively to us from the margins of the technological landscape.'[5] Yet this caution is muted by Ballard's apparent celebration of the freedom and exhilaration to be found in the extremes of human behaviour. A landscape that seemingly offers no escape from the mundane reality of everyday life soon subverts these expectations, provoking us to react against the conformity of our surroundings.

If the demise of the Situationists has been taken to mark the end of the avant-garde period[6] then Ballard remained happily oblivious to this. For through the late sixties and early seventies, he continued to produce a series of works

explicitly drawing upon surrealist imagery and techniques, compiling in his fiction a more detailed psycho-geographical map of the modern urban hinterland than any situationist survey could ever hope to replicate. His fragmentary 'novel' of iconic sixties images, *The Atrocity Exhibition*, is notable both for its use of surrealist collage and the *détournement* of famous media figures such as Marilyn Monroe and John F Kennedy, who appears, through a parody of Alfred Jarry, in *The Assassination of John Fitzgerald Kennedy Considered as a Downhill Motor Race*. While, in his loose trilogy of urban breakdown (*Crash*, *Concrete Island* and *High-Rise*), Ballard illustrates how modern technology 'offers an endless field-day to any deviant strains in our personalities'.[7] These works clearly demonstrate that it is the novelist rather than the theoretician who is best able to capture the relationship between the urban environment and human behaviour.

Ballard describes modern life in advanced industrial societies as characterised by a loss of emotional sensitivity. Amidst the barrage of media imagery to which we are subjected, our emotional response is blunted and we become unable to engage directly with our surroundings without the mediated images of television and advertising. The result, as the Situationists proclaimed, is the banalisation of everyday life, as we struggle to consume our way out of this sensory impasse. But Ballard's fiction challenges this assumption and presents these non-places at the perimeter of our lives (and increasingly representative of all urban space) as liable not merely to

provoke boredom but to result in more extreme forms of behaviour that increasingly mirror the violent and sexualised imagery that surrounds us. In this sense the spectacular society will, of its own accord, produce that element of unpredictable and even revolutionary behaviour that Debord himself hoped to engineer. Unfortunately, however, whether driving along the Westway or sealed within gated communities, the forms of behaviour attributable to these clearly demarcated zones will, according to Ballard, be unlikely to resemble the ambient and harmonious spaces the Situationists envisaged. Instead, they will constitute a full-scale descent into savagery, sexual perversity and complete breakdown as the brand of community living engineered by the tower block or executive village dissolves into a series of individual retreats into personal obsession.

Ballard's work displays none of the accoutrements with which psychogeography has become popularly associated and there is no sense of the historical or literary tradition that characterises Iain Sinclair's work. Indeed, Ballard is dismissive of London precisely because of the weight of its historical heritage, commenting:

I regard the city as a semi-extinct form. London is basically a nineteenth-century city. And the habits of mind appropriate to the nineteenth century, which survive into the novels set in the London of the twentieth century, aren't really appropriate to understanding what is really going on in life today. I think the suburbs are more interesting than people will let on. In the suburbs you find

uncentred lives... So that people have more freedom to explore their own imaginations, their own obsessions.[8]

Also absent from Ballard's fiction is the occult connectivity that Ackroyd espouses, while even the avant-garde imagery of his early work is absent in *Crash* and its sequels. As for the stroller or idle pedestrian, he is likely to be swiftly run over if he is unfortunate enough to find his way into a Ballard novel, while *Concrete Island* clearly demonstrates the isolated and barren fate awaiting those urban Crusoes who deviate from the motorway. By dispensing with these themes, however, Ballard is able to pare down his prose into a simple allegory of modern urban life that focuses solely upon the relationship between individual and environment, facilitated by the freedom from human interaction that the motorway or tower block affords. This is psychogeography rendered in its most stark and unforgiving manner, and these texts have mapped, in advance of anyone else, the layout of a future city characterised by a transient population living lives of anonymous isolation.

Iain Sinclair and the Rebranding of Psychogeography

Walking is the best way to explore and exploit the city; the changes, shifts, breaks in the cloud helmet, movement of light on water. Drifting purposefully is the recommended mode, tramping asphalted earth in alert reverie, allowing the fiction of an underlying pattern to reveal itself.

Iain Sinclair, *Lights Out for the Territory.*[9]

If there is one person who, more than any other, is responsible for the current popularity that psychogeography enjoys, then it is Iain Sinclair. Born in Wales but resident in London for the last thirty years, Sinclair has undertaken a complex 'London Project' which incorporates a series of poems and novels, as well as documentary studies and films, that restore the city to its dominant psychogeographical position and which place Sinclair at the heart of this revival. Sinclair's work has little overt connection with the ideological agenda of the Situationists but is heavily indebted both to the surrealist drift of Breton and Aragon and to the visionary tradition of London writers from William Blake to Arthur Machen. But most significant, at least as far as Sinclair's early work *Lud Heat* is concerned, is the influence of Alfred Watkins and his discussion of ley lines.

Lud Heat was published in 1975 but Sinclair's reputation was established retrospectively through Peter Ackroyd's celebrated novel *Hawksmoor* which developed many of his ideas. Sinclair's prose-poem first proposes the occult alignment of Hawksmoor's remaining London churches, arguing that 'lines of force' can be mapped between these churches to reveal the true but hidden relationship between the city's financial, political and religious institutions:

> A triangle is formed between Christ Church, St George-in-the-East and St Anne, Limehouse. These are centres of power for those territories; sentinel, sphinx-form, slack dynamos abandoned as the culture they supported goes into retreat. The power remains latent, the frustration mounts on a current of animal magnetism, and victims are still claimed.

St George, Bloomsbury, and St Alfege, Greenwich, make up the major pentacle-star. The five card is reversed, beggars in snow pass under the lit church window; the judgement is 'disorder, chaos, ruin, discord, profligacy.' These churches guard or mark, rest upon, two major sources of occult power: The British Museum and Greenwich Observatory.[10]

Sinclair's delightful blend of paranoia, occult imagination and local London history places him firmly within a tradition of earlier London visionaries. While his later work, in particular his accounts of walks in and around London in *Lights Out for the Territory* and *London Orbital*, invokes the spirit of the Surrealists and their desire to unearth hidden aspects of the city as they drift through the streets. Sinclair, however, is no *flâneur*, for he is aware of the necessary transformation this figure has undergone in order to face the challenge of the modern city:

The concept of 'strolling', aimless urban wandering, the flâneur, had been superseded. We had moved into the age of the stalker; journeys made with intent – sharp-eyed and unsponsored. The stalker was our role-model: purposed hiking, not dawdling, nor browsing. No time for the savouring of reflections in shop windows, admiration for the Art Nouveau ironwork, attractive matchboxes rescued from the gutter. This was walking with a thesis. With a prey... The stalker is a stroller who sweats, a stroller who knows where he is going, but not why or how.[11]

Sinclair's peculiar form of historical and geographical research displays none of the rigour of psychogeographical theory and is overlaid by a mixture of autobiography and literary eclecticism. But beneath this allusive surface, lies a political engagement and a clear anger directed against the legacy of Thatcherite redevelopment. Once again this political dimension owes little to the revolutionary fervour of the Situationists but shares a great deal with Aragon's *Paris Peasant*. For *Lights Out for the Territory*, with its exploration of the hidden city and memorial to a lost London, replicates Aragon's anger at the destruction of the Parisian Arcades. In an interview with *Fortean Times*[12] Sinclair acknowledges this debt to Aragon, writing of surrealism, 'I liked the notion of it, but it wasn't exactly what I was doing. I liked their notion of finding strange parks at the edge of the city, of creating a walk that would allow you to enter into a fiction.' Here, he describes his own use of psychogeography, adding: 'By the time I was using the term it was more like a psychotic geographer! It was much less philosophically subtle than some of the previous attempts, more of a raging bull journey against the energies of the city.'

Sinclair has been a prolific writer and *Lud Heat* was followed by *Suicide Bridge* as well as novels, including *White Chappell Scarlet Tracings*, *Downriver* and *Radon Daughters*, which portray a city inseparable from its past, both real and imagined. London's topography is reconstituted through a superimposition of local and literary history, autobiographical elements and poetic preoccupations, to

create an idiosyncratic and highly personal vision of the city. Sinclair has since moved outwards from his spiritual home in Hackney to encompass the wider city, and *London Orbital*, an account of his epic walk around the M25, takes him into territory previously associated with JG Ballard. Here, once again, Sinclair offers his own highly successful brand of psychogeography in which urban wanderer, local historian, avant-garde activist and political polemicist meet and coalesce.

In fact, so successful, so recognisable and so ubiquitous has Sinclair's method become that he appears to have inaugurated an entirely new genre of topographical writing centred upon London which has gone some way towards displacing Debord and situationism as the official psychogeographical brand. Alert to this development, Sinclair writes:

> For me, it's a way of psychoanalysing the psychosis of the place in which I happen to live. I'm just exploiting it because I think it's a canny way to write about London. Now it's become the name of a column by Will Self, in which he seems to walk about the South Downs with a pipe, which has got absolutely nothing to do with psychogeography. There's this awful sense that you've created a monster. In a way I've allowed myself to become this London brand. I've become a hack on my own mythology, which fascinates me. From there on in you can either go with it or subvert it.[13]

Sinclair's own take on psychogeography does appear to have

become a victim of its own success, taking on the very appearance of a marketable brand that psychogeography has traditionally sought to undermine. With its appealing blend of the occult and the political, of the hidden and the neglected, Sinclair's work presents a new way of apprehending the city that has spawned a host of imitators. Psychogeography, at least as far as it is applied to London, increasingly comes to resemble an institution with Sinclair at its head and this has inevitably blunted its impact, as what was once a marginal and underground activity is now afforded mainstream recognition. In this respect, Sinclair joins Peter Ackroyd as something of a London-themed publishing phenomenon and it is around this literary axis that psychogeography in its newly popular form now rotates.

Peter Ackroyd and the New Antiquarianism

If Iain Sinclair's blend of occult paranoia and historical investigation rebrands psychogeography in a new format that completely dispenses with situationist theory in favour of a return to earlier literary and esoteric traditions, Peter Ackroyd goes a step further, moulding psychogeography into a conservative and irrational model diametrically opposed in both spirit and practice to Debord's conception.

To be fair to Ackroyd, he would certainly not describe himself as a psychogeographer and he has displayed some disdain for the term. But despite this, the publication of his mammoth *London: the Biography* in 2000 has been hailed as

the moment when psychogeography entered the mainstream.[14]

Ackroyd's *Hawksmoor* is informed by Sinclair's earlier occult alignments in *Lud Heat* but is extended to reflect Ackroyd's own highly contentious and idiosyncratic theory of temporal and spatial correspondences within London. Reiterated consistently throughout Ackroyd's fiction, as well as governing the structure of *London: The Biography*, is his recognition of zones within the city which display chronological resonance with earlier events, activities and inhabitants. In a manner redolent of the pre-situationist segregation of the city according to emotional ambience, Ackroyd writes: 'Yet perhaps it has become clear that certain activities seem to belong to certain areas, or neighbourhoods, as if time were moved or swayed by some unknown source of power.'[15]

This theory is leant fictional support within *Hawksmoor* where Ackroyd's detective muses upon the tendency of murderers and their victims to return repeatedly through the generations to similar locations as if drawn by some malevolent force, noting that 'certain streets or patches of ground provoked a malevolence which generally seemed to be quite without motive.'[16] Certainly Ackroyd's gothic re-enactments favour the darker side of London's history, but in replaying Sinclair's thesis that there is a criminal correspondence within the alignment of Hawksmoor's churches, Ackroyd is developing a kind of gothic psychogeography that explores, as does Ballard in a contemporary setting, the more extreme forms of

behavioural response provoked by the city.

Where Ackroyd parts company with Ballard and Sinclair, is in his belief that these spatial correspondences are not only governed by historical resonances inherited from the past, but are also subject to temporal patterns through which the city may be subdivided once again: 'The nature of time is mysterious,' proclaims Ackroyd, 'Sometimes it moves steadily forward, before springing or leaping out. Sometimes it slows down and, on occasions, it drifts and begins to stop altogether.'[17]

Ackroyd labels this idea 'chronological resonance' and argues that these temporal patterns not only have clearly observable affects upon the behaviour of Londoners themselves, but also go some way to defining individual character and identity:

'Just as it seems possible to me that a street or dwelling can materially affect the character and behaviour of the people who live within them, is it not also possible that within our sensibility and our language there are patterns of continuity and resemblances...'[18]

Ackroyd follows the implications of his theory to their logical, but unverifiable, conclusions, eventually moving from London to the country as a whole and identifying two opposing strands of national identity. On the one hand, there is the secular and objective inquiry of rational Protestantism, the prevailing orthodoxy of the last 300 years, and on the other, what he describes as a Catholic or religious sensibility characterised by an exuberant irrationality and visionary sense of place. This latter

irrational, even sacred, impulse reveals the city as it truly is, and allows its adherents, even today, to recognise the magical that underlies the mundane:

> Now, at the end of the twentieth century, we are beginning to realise that there are other enchanted areas in London which remain visible and powerful to anyone who cares to look for them... the enchantment is one of place and time; it is as if an area can create patterns of interest, or patterns of habitation, so that the same kinds of activity... seem to emerge in the same small territory.[19]

Those Londoners attuned to this revelatory vision of the city, Ackroyd labels 'Cockney Visionaries' and amongst their number he ranks Blake, Machen and Iain Sinclair.[20] At this point, Ackroyd's sense of an enchanted <u>city</u> behind our own echoes that of the Lettrists, but his interpretation leads to rather different consequences than those documented in 1950s Paris. While lettrism gave way to the objective rigour espoused by the Situationists, Ackroyd's theory grows ever more mystical and all-embracing, becoming a quest for the defining characteristics of English national identity in which the spirit of scientific inquiry is rebutted by Ackroyd's irrational and wholly subjective sense of time and place. Even more damaging to Ackroyd's psychogeographical credentials, at least in their situationist form, is his insistence that the city is eternal and illimitable, and governed by a cyclical current that views the present merely as the past revisited. What this leaves us with is not the revolutionary demand for change with which

psychogeography is usually associated, nor even the anti-Thatcherite agenda that colours so much contemporary psychogeographical discourse. Instead, Ackroyd leaves us stranded within a kind of eternal recurrence in which the flux of the present is subsumed within a mystical sense of eternal stasis that renders all political engagement redundant. In short, what has been described as a 'neo-conservative attempt to contain change.'[21]

Ackroyd's antiquarian sense of an endlessly recycled past negates any attempt by individuals to change the fundamental nature of their environment and renders them little more than passive observers in a city that is essentially self-regulating. 'Sometimes it seems to me,' writes Ackroyd, 'the city itself creates the conditions for its own growth, that it somehow plays an active part in its own development like some complex organism slowly discovering its form. Certainly it affects the lives, the behaviour, the speech, even the gestures of the people who live within it.'[22]

Ultimately, Ackroyd is expressing a form of behavioural determinism in which the city does not so much shape the lives of its inhabitants as dictate it. Within a cycle of decline and regeneration that spans millennia, the actions and beliefs of today's inhabitants are seemingly of little or no consequence. If psychogeography is the behavioural impact of place, then Ackroyd's historico-mystical version is at odds not only with its revolutionary forbears but also, despite any superficial similarities, with the current brand favoured by Iain Sinclair and his acolytes. Here, Ackroyd

shows his disdain for the term to be well placed, for the tradition that he attempts to resurrect fails even to acknowledge those changes that psychogeography seeks to implement.

Stewart Home and the London Psychogeographical Association

Rebels and bohemians traverse cities, scattering signs, staging enigmas, leaving coded messages, usurping the territorial claims of priests and kings by transforming the social perception of specific urban sites. Both the London Psychogeographical Association and the Manchester Area Psychogeographic use their newsletters to publicise regular gatherings that interested parties may attend. On these trips, anything or nothing at all may happen. These are possible appointments and sometimes only one intrepid psychogeographer attends. Other events are huge gatherings of urban tribes bent on emotionally remapping the cities in which they dwell. Psychogeographers pass each other like ships in the night, show up late or not at all.

Stewart Home, *Mind Invaders*.[23]

Stewart Home was a prime mover within the resurgence of psychogeographical and avant-garde groups in the 1990s but his relationship with these groups remains tangential and obscure. He is best viewed as the ringmaster of an avant-garde circus comprising groups and individuals such as the Neoist Alliance, the New Lettrist International and, most prominently, the London Psychogeographical Association (LPA) reconvened in 1992, some 35 years after

the dissolution of the original group of that name.

Along with fellow travellers that have included, amongst others, Richard Essex, Fabian Tompsett and Tom Vague, Home has been responsible for a deluge of psycho-geographical pamphlets, statements and events, which in recalling the pranksterism of the Lettrist International, have this time managed to inject some much needed humour into the proceedings. Often operating under group monikers such as the Neoist Alliance, Home combines a peculiar blend of occultism, avant-garde theorising and radical left politics in what he terms the 'avant-bard', a concept whose incoherence and presentation in weighty disputations on Hegel, situationism and class war is only saved from tedium by Home's clear inability to take himself or his subject seriously. This ironic tone is constant throughout the proclamations of both the Neoist Alliance and the LPA, many of whose contributions to psychogeographical research are to be found in the collection *Mind Invaders*, edited by Home. Here we find LPA newsletters entitled *Nazi Occultists Seize Omphalos*, *Smash the Occult Establishment* and *Who Rules Britain?* and in a language familiar to readers of Iain Sinclair, the true history of the East End is revealed:

> Many people believe that Greenwich is in fact the omphalos – or spiritual centre – of the British Empire. However, those with a deeper understanding of feng shui, the ancient Chinese art of land divination, will recognise

that the actual omphalos must be on the Isle of Dogs, protected by water on all sides. Those who visit Mudchute – a piece of park mysteriously built as an exact replica of an ancient hill-fort – will find a special staircase leading to a cobbled circle. This is the omphalos, the spiritual centre, where the magus John Dee conjured up the British Empire in the presence of Christopher Marlowe, four hundred years ago this year. However, using the ley line for such evil purposes necessitated the sacrifice of a human life. A psychic attack on Christopher Marlowe and his friends led to a brawl in which the famous playwright died.[24]

In a piece entitled *The Unacceptable Face of Contemporary Psychogeography*, the LPA claim that, 'We offer no attempt to "justify" or "rationalise" the role of magic in the development of our themes; it is sufficient that it renders them completely unacceptable'[25], and both here and throughout Home's work, the role of provocation is always given precedence over the factual accuracy of the content. Indeed, it would be more absurd than any of Home's antics for the reader to take him at face value. While taking on the mantle of Ralph Rumney's pre-situationist movement, both the LPA and Home offer, not so much a continuation of Debord's sentiments, as an antidote to their excruciating portentousness. It is in this spirit that the article *Why Psychogeography?* outlines the following role for its subject: 'By drawing upon ancient song lines which reassert themselves within the modern urban environment, psychogeography as the practical

application of anti-Euclidean psychogeometry offers the third pole in the triolectic between the fake universalism of modernism and the universal virtuality of post-modernism.'[26]

A description of Home's work in the NME as, 'extremely entertaining bollocks, combining gutter-nutter tabloidese with bitchy art-student gibberish'[27] comes to mind here, and this type of discourse, with its characteristic theoretical incoherence, has become the hallmark of many such psychogeographical offerings from this period. Such activities are not confined to London, however, but are replicated by similar groups abroad, most notably through the Italian collective known as Luther Blissett. Yet, just as the Luther Blissett Project now authors 'respectable' mainstream historical blockbusters, so too has Stewart Home, despite the publisher-resistant titles of books such as *Cunt* and *Blowjob*, increasingly gained mainstream recognition. Today, Home is less closely identified with his role as art-terrorist and sponsor of events such as the Festival of Plagiarism, and better known for novels such as *69 Things to Do With a Dead Princess* and *Down and Out in Shoreditch and Hoxton*, in which he appears to have cornered the market in ultra-violent, sexually graphic but theoretically alert accounts of London lowlife.

Home's parodic insistence on presenting himself as wind-up merchant *par excellence* cannot completely obscure the accuracy of his critical commentary upon the avant-garde movements that he has sought to revive.

His obvious amusement at the provocations that he delights in creating is mirrored in a healthy critical awareness of the shortcomings of earlier psycho-geographical activity. For example, in a piece entitled *The Palingenesis of the Avant-Garde*, he describes the all too familiar boast that Debord and Vaneigem had managed to supersede their avant-garde ancestry, noting that 'all the Situationists actually succeeded in doing was restating the failures of Dada and Surrealism in Hegelian terminology, with the inevitable consequence that their critique was in many ways much less "advanced" than that of their "precursors".'[28]

Elsewhere, in his history of the post-war avant-garde, *The Assault on Culture*, Home makes explicit the shared heritage that connect these myriad groups and which Debord was so keen to transcend. Home's ambitions seem rather less grandiose, and in combining a humorous approach with an awareness both of psychogeography's roots as a highly personal enterprise and its relationship to earlier traditions, he appears to have successfully wrong-footed those critics unable to work out what he's up to and unsure how to respond. Those highlighting the obvious limitations of his prose style tend to miss the point, and as Iain Sinclair has suggested, with ideas as obviously crazy as his, you have to trust him. Home has said that his avant-bardism follows no programme or agenda, and through his ironic undermining of his own work and critical responses to it, Home has effectively liberated psychogeography from the constraints of any

one set of practices or aims, creating a highly effective weapon in his assault upon the artistic establishment.

Patrick Keiller and the Return of Robinson

The true identity of London is in its absence. As a city, it no longer exists. In this alone it is truly modern: London was the first metropolis to disappear.

Patrick Keiller, *London*.[29]

In his 1994 film *London*, Patrick Keiller describes the city through the eyes of his unnamed narrator and his companion Robinson. These latter-day *flâneurs* reveal a city increasingly defined by its absence. An absence of identity, of effective government and of visible economic output, of public space, of community, even, in Thatcher's terms, of society. The psychogeographer sent out in early 1990s London to report upon the city's peculiar ambiance is likely to be frustrated, for the London that Keiller illustrates is one of emptiness, 'a place of shipwreck and the vision of Protestant isolation.'[30]

Keiller's film takes the form of a fictional journal resembling, in its imaginative reworking of facts and impressions, Defoe's *Journal of the Plague Year*.[31] Defoe is a recurring point of reference in Keiller's work and his *Tour Through the Whole Island of Great Britain* informs Keiller's sequel to *London*, *Robinson in Space*, in which Robinson extends his quest outwards across the UK. In this sense, Keiller's work provides a suitable end to my discussion of

psychogeography, returning to my account of Defoe at the outset of this book. Robinson returns in Keiller's films in the form of a 'disenfranchised, would-be intellectual, petit bourgeois part-time lecturer' who is seeking to solve the 'problem of London', which, according to Keiller, seems to be, in essence, that London isn't Paris.[32] Keiller's films are preoccupied with the two divergent traditions that this book has explored: on the one hand, the European, or more particularly Parisian, tradition of urban writing from Poe and Baudelaire to Rimbaud and Aragon, and on the other, the home-grown tradition which takes London as its centre and which is exemplified by Defoe and Robinson. *London* seeks out traces of that historic moment when the *flâneur* left nineteenth-century Paris to reach London for the first time, symbolised by the arrival of Apollinaire and Rimbaud, and questions why the European sensibility that they represented was unable to take root and flourish here. What is it about the nature of London, then as now, that somehow resists the figure of the stroller, forcing him to take on a more committed and engaged role within the life of the city? Keiller's film demonstrates how a primarily artistic sensibility mutates upon the streets of London into something more political, as a meditation on the lives of these nineteenth-century writers and artists gives way to a description of London's decline, symbolised by Thatcherite mismanagement and hostility to the city, and resulting in a sense of fragmentation as the city's community, both geographically and psychically, comes under threat.

Robinson in Space continues this psychogeographic

quest, moving away from the city to provide a 'document of transformation, a discovery of all these out-of-the-way places where they make plasterboard'[33] and entering the hinterland previously explored by Ballard and Sinclair. Here, Robinson seeks out the results of a particularly English form of capitalism, built upon invisible sources of wealth, whose only concrete monument is a nation of endlessly replicated retail parks and service stations. This would seem an unlikely source of psychogeographical material and yet Keiller is alert to the revival of interest in situationist and psychogeographical ideas that occurred during the 1990s and his film begins with Vaneigem's call in his *Revolution of Everyday Life* for a bridge to be built between imagination and reality.[34] However, the bland landscapes depicted in Keiller's film seem antithetical to the imaginative reworking the Situationists promulgated and reveal a desolate topography of anonymous industrial plants linked by congested and failing transport systems and ceaselessly monitored by a sophisticated surveillance system. In this realm, Robinson, the *flâneur*, the psychogeographer, falls victim to depression and paranoia as he becomes increasingly obsessed by the enforced secrecy that separates him from this environment, keeping him at arm's length and constantly denying him access. Keiller's films offer a humorous and deadpan commentary on the state of contemporary Britain but ultimately offer little encouragement to would-be strollers. London and its environs are, as Rimbaud and Apollinaire witnessed a century earlier, hostile to their wanderings, but unlike the

Situationists in Paris, the psychogeographic revival in nineties London has not coincided with a revolutionary uprising against this bland and increasingly Americanised environment. On the contrary, as Keiller makes clear in an interview with Steve Hanson, psychogeography today has divorced itself from the political concerns and obligations of the Situationists, increasingly becoming preoccupied with its own practices as an end in itself: 'The Situationists saw their explorations at least partly as preliminary to the production of some kind of new space, but in 1990s London, they seemed to have become an end in themselves, so that "psychogeography" led not to avant-garde architecture such as Constant's "New Babylon", but to, say, the *Time Out Book of London Walks*'.[35]

Instead of seeking to change their environment, psychogeographers in their contemporary incarnation seem satisfied merely to experience and record it. In this sense, psychogeography has overlooked its political and ideological roots in situationism in favour of a return to the primarily artistic concerns of earlier avant-garde and literary traditions. These authors certainly voice dissatisfaction with the political shortcomings of the present but are unable to supply any practical measures to alleviate their concerns. Even figures such as Stewart Home, who has successfully combined a literary career with the promotion of various psychogeographical organisations, reserves his practical interventions solely for the artistic realm. Despite his claim that psychogeography is a tool of class war, this warfare is conducted not on the

street but largely through the media. Of course, it is through the media that psychogeography has gained a degree of mainstream acknowledgement and it is through the varied mediums of the novel and poetry, of film and internet, that it is able to leave a lasting record and to establish a tradition of its own. But, with the return of Robinson in Keiller's work, we are recalled finally to Defoe himself in whom the figure of novelist, pamphleteer and radical combined to provide a lasting template for a future psychogeography in which literary endeavour and political activism are once again inseparable.

Notes

[1] Will Self, quoted in *Private Eye: Mediaballs Vol 2, 2005*, p43

[2] See Laity, P. 'Dazed and Confused' in *London Review of Books*, 28 November 2002, p24–8

[3] Guy Debord, *The Society of the Spectacle*, quoted in Luckhurst, p123

[4] JG Ballard, *Crash*, p32

[5] JG Ballard , *Crash*, Introduction (1995)

[6] Peter Wollen, quoted in Luckhurst, p83

[7] JG Ballard, *Concrete Island*, Introduction (1994)

[8] Iain Sinclair, *Crash*, (BFI Modern Classics), p84

[9] Iain Sinclair, *Lights Out for the Territory*, p4

[10] Iain Sinclair, *Lud Heat*, p15

[11] Iain Sinclair, *Lights Out for the Territory*, p75

[12] www.forteantimes.com/features/interviews/37/ iain_sinclair.html

13 Iain Sinclair in interview with Stuart Jeffries, *The Guardian*, Saturday April 24, 2004. Also available at www.classiccafes.co.uk/isinclair.htm

14 Phil Baker, p328

15 Peter Ackroyd, *London: The Biography*, p774

16 Peter Ackroyd, *Hawksmoor*, p116

17 Peter Ackroyd, *London: The Biography*, p661

18 Peter Ackroyd, 'The Englishness of English Literature' *The Collection*, p339

19 Peter Ackroyd, 'William Blake, a Spiritual Radical' *The Collection*, p355

20 Peter Ackroyd, 'The Englishness of English Literature' *The Collection*, p346

21 Phil Baker, p328

22 Peter Ackroyd, 'London Luminaries and Cockney Visionaries' *The Collection*, p342

23 Stewart Home, 'Introduction: Mondo Mythopoesis' *Mind Invaders*, pX

24 Ibid, p29

25 Ibid, p152

26 Ibid, p136

27 Stewart Home, *Confusion Incorporated*, rear cover

28 Ibid, p49

29 Patrick Keiller, *London* and quoted by Keiller in 'London in the Early 1990s' Kerr and Gibson (Eds) *London from Punk to Blair*, p357

30 Patrick Keiller, 'London in the Early 1990s', p356

31 Keiller makes this comparison himself. Ibid, p354

32 Ibid, p354

33 Patrick Keiller, *Robinson in Space*, p232
34 Raoul Vaneigem, *The Revolution of Everyday Life*, quoted in Keiller, *Robinson in Space*, p1
35 Patrick Keiller interviewed by Steve Hanson in *Street Signs*, Spring 2004 at http://steveaitch.wordpress.com/2009/10/04/718/

Psychogeographical Groups, Organisations & Websites

Any cursory internet search under the term 'psycho-geography' will reveal a plethora of sites featuring psychogeographical ideas and organisations as well as providing links to many of the texts I have explored in this book. Due to the clandestine and often transitory nature of these groups, contact details quickly become obsolete, but for those seeking an entry point into this daunting mass of information, Stewart Home's *Mind Invaders* provides a useful summary of some of the key players in both psycho-geography and across the spectrum of those marginal and largely unclassifiable activities loosely described as 'cultural terrorism'. Needless to say, many of these groups are now redundant and Home's book, published in 1997, inevitably provides last known addresses rather than current contact information. In the spirit of plagiarism that he has so enthusiastically endorsed I have copied the details he provides of some of the more prominent groups below. For those looking for more up to date contact details as well as an online library of psychogeographical texts and associated writings, I have also supplied a list of the most useful and comprehensive websites.

In a final confirmation of the now mainstream status of many previously 'underground' organisations broadly associated with psychogeography, the recently published *Lonely Planet Guide to Experimental Travel* is also worth consulting.

Psychogeographical Groups & Affiliated Organisations:

Affinity Project
www.affinityproject.org

Association of Autonomous Astronauts

For details of associations worldwide visit
www.uncarved.org/AAA/groups.html

Decadent Action, BM Decadence, London WC1N 3XX
www.monoculartimes.co.uk/counterculture/
decadentaction.shtml

Dialectical Immaterialism, PO Box 22142,
Baltimore, MD 21203 USA
www.thing.de/projekte/7:9%23/berndt_dialectical_
imm.html

Glowlab
www.christinaray.com

London Perambulator
www.londonperambulator.wordpress.com

London Psychogeographical Association, Box 15,
138 Kingsland High Street, London E8 2NS
www.unpopular.demon.co.uk/lpa/organisations/lpa.html

Luther Blissett Project
www.lutherblissett.net/

Manchester Area Psychogeographic
www.uncarved.org/turb/articles/map-int.html

Materialist Psychogeographic Affiliation (MPA)
www.materialistpsychogeography.co.uk

New York Psychogeographical Association
www.notbored.org/the-nypa.html

Nottingham Psychogeographical Unit
http://fasica.altervista.org/npu/index.htm

Psychogeography in Prague
http://devenirnomada.blogspot.com/2005/03/
psychogeography-in-prague_24.html

Toronto Psychogeography Society
www.psychogeography.ca/

Urban Adventure in Rotterdam
www.xs4all.nl/~kazil/

Wrights & Sites
www.mis-guide.com/

Other sites of interest include:

Bureau of Public Secrets
www.bopsecrets.org/

Classic Cafes (The Psychogeography of the Café)
www.classiccafes.co.uk/Psy.html

The Flâneur: Independent Art & Culture Journal
www. flaneur.me.uk/

Headmap Manifesto
http://tecfa.unige.ch/~nova/headmap-manifesto.PDF

Not Bored
www.notbored.org

Nothingness.org & The Situationist Archives
www.nothingness.org/SI/

Psychogeography Links Collection
(compiled by Michelle Kasprzak)
www.year01.com/forum/issue12/links.html

Situationist International Online
www.cddc.vt.edu/sionline/index.html

Social Fiction
www.socialfiction.org/

Stewart Home Society
www.stewarthomesociety.org/

Bibliography & Further Reading

In consulting this bibliography a couple of books deserve particular attention: for those interested in the intersection between walking and literature and, in particular, the tradition of literary wandering that runs, or rather strolls, from Blake to Benjamin and de Quincey to Debord, Rebecca Solnit's *Wanderlust: A History of Walking* provides the definitive account. This tradition is reiterated and explored through the notion of *genius loci* in Peter Woodcock's *This Enchanted Isle: The Neo-Romantic Vision from William Blake to the New Visionaries*. Those interested in situationist and pre-situationist documents should consult Ken Knabb's exhaustive *Situationist International Anthology* while those looking for a brief overview of the themes discussed in this book might like to read Phil Baker's 'Secret City: Psychogeography and the End of London' in Kerr & Gibson (Eds) *London from Punk to Blair*.

Ackroyd, Peter *Hawksmoor*, London: Hamish Hamilton, 1985
 — *Blake*, London: Sinclair-Stevenson, 1995
 — *London: The Biography*, London: Chatto & Windus, 2000

 — *The Collection*, London: Chatto & Windus, 2001

Andreotti & Costa (Eds) *Theory of the Dérive and Other Situationist Writings on the City*, Barcelona: Museu d'art Contemporani, 1996

Antony, Rachael & Henry, Joel *The Lonely Planet Guide to Experimental Travel*, London: Lonely Planet Publications, 2005

Baker, Brian 'Maps of London Underground: Iain Sinclair and Michael Moorcock's Psychogeography of the City' in *Literary London: Interdisciplinary Studies in the Representation of London*, at http://homepages.gold.ac.uk/londonjournal/march2003/baker.html

Baker, Phil 'Secret City: Psychogeography and the End of London' in Kerr & Gibson (Eds) *London from Punk to Blair*, London: Reaktion Books, 2003

Ballard, JG *The Atrocity Exhibition*, London: Jonathan Cape, 1970

 — *Crash*, London: Jonathan Cape, 1973

 — *Concrete Island*, London: Jonathan Cape, 1974

 — *High-Rise*, London: Jonathan Cape, 1975

Baudelaire, Charles *The Painter of Modern Life & Other Essays*, London: Phaidon Press, 1995

Benjamin, Walter *Charles Baudelaire: A Lyric Poet in the Era of High Capitalism*, London: Verso, 1997

 — *The Arcades Project*, Cambridge MA: Belknap Press, 1999

Blake, William *Complete Writings*, Oxford: Oxford University Press, 1966

Breton, André *Manifestoes of Surrealism*, Ann Arbor:

University of Michigan, 1972

 – *Nadja*, New York: Grove Press, 1960

Céline, Louis-Ferdinand *Journey to the End of the Night*, London: John Calder, 1988

Debord, Guy *The Society of the Spectacle*, London: Rebel Press, 1992

Defoe, Daniel *Robinson Crusoe*, London: Penguin, 1966

 – *A Tour Through the Whole Island of Great Britain*, London: Penguin, 1971

 – *A Journal of the Plague Year*, London: Penguin, 2003

De Certeau, Michel *The Practice of Everyday Life*, Berkeley CA: University of California, 1988

De Maistre, Xavier *A Journey Around My Room*, London: Hesperus, 2004

De Quincey, Thomas *Confessions of an English Opium-Eater*, London: Penguin, 1997

Ford, Simon *The Situationist International: A User's Guide*, London: Black Dog, 2005

Gordon, Elizabeth *Prehistoric London: Its Mounds and Circles*, London: Covenant Publishing, 1914

Home, Stewart *The Assault on Culture: Utopian Currents from Lettrisme to Class War*, Edinburgh: AK Press, 1991

 – *The House of Nine Squares: Letters on Neoism, Psychogeography and Epistemological Trepidation*, London: Invisible Books, 1997

 – (Ed) *Mind Invaders: A Reader in Psychic Warfare, Cultural Sabotage and Semiotic Terrorism*, London: Serpents Tail, 1997

 – *Confusion Incorporated: A Collection of Lies, Hoaxes and*

Hidden Truths, Hove: Codex, 1999

Huysmans, Joris-Karl *Against Nature (À Rebours)*, London: Penguin, 1973

Jenks, Chris 'Watching Your Step: The History and Practice of the *Flâneur*' in Jenks (Ed) *Visual Culture*, London: Routledge, 1995

Kafka, Franz *Amerika (The Man Who Disappeared)*, London: Penguin, 1970

Kees, Weldon *Collected Poems*, London: Faber, 1993

Keiller, Patrick *London*, London: BFI, 1993
- *Robinson in Space*, London: Reaktion Books, 1999
- 'London in the Early 1990s' in Kerr & Gibson (Eds) *London From Punk to Blair*, London: Reaktion Books, 2003

Knabb, Ken (Ed) *Situationist International Anthology*, Berkeley CA: Bureau of Public Secrets, 1981

Laity, Paul 'Dazed and Confused' in *London Review of Books*, London: November 28, 2002, p24–28

Lautréamont, Comte De *Maldoror and Poems*, London: Penguin, 1978

Luckhurst, Roger '*The Angle Between Two Walls*': *The Fiction of JG Ballard*, Liverpool: Liverpool University Press, 1997

McDonough, Tom (Ed) *Guy Debord and the Situationist International: Texts & Documents*, Cambridge MA: MIT Press, 2004

MacFarlane, Robert *Mountains of the Mind*, London: Granta, 2003
- 'A Road of One's Own' *Times Literary Supplement*, October 7, 2005

Machen, Arthur *The London Adventure, or the Art of Wandering*, London: Martin Secker, 1924

 — *The Three Impostors*, London: Everyman's Library, 1995

Marcus, Greil 'The Long Walk of the Situationist International' in McDonough (Ed) *Guy Debord and The Situationist International: Texts & Documents*, Cambridge MA: MIT Press, 2004

 — *Lipstick Traces: A Secret History of the Twentieth Century*, London: Secker & Warburg, 1990

Mighall, Robert (Ed) Robert Louis Stevenson *The Strange Case of Dr Jekyll & Mr Hyde and Other Tales of Terror*, London: Penguin, 2002

Nadeau, Maurice *The History of Surrealism*, London: Penguin, 1978

Palmer, Christopher (Ed) *The Collected Arthur Machen*, London: Duckworth, 1988

Petit, Chris *Robinson*, London: Granta, 2003

Plant, Sadie *The Most Radical Gesture: The Situationist International in a Postmodern Age*, London: Routledge, 1992

Poe, Edgar Allan 'The Man of the Crowd' in *The Fall of the House of Usher and Other Tales*, London: Penguin, 2003

Sadler, Simon *The Situationist City*, Cambridge MA: MIT Press, 1982

Sinclair, Iain *Lights Out for the Territory*, London: Granta, 1997

 — *Lud Heat & Suicide Bridge*, London: Granta, 1998

 — *Crash* (BFI Modern Classics), London: BFI Publishing, 1999

- *Dark Lanthorns: David Rodinsky as Psychogeographer*, Uppingham: Goldmark, 1999
- (with Marc Atkins) *Liquid City*, London: Reaktion, 1999
- (with Rachel Lichtenstein) *Rodinsky's Room*, London: Granta, 1999
- *London Orbital*, London: Granta, 2002

Solnit, Rebecca *Wanderlust: A History of Walking*, London: Verso, 2001

Stein, Howard F & Niederland, William G (Eds) *Maps from the Mind: Readings in Psychogeography*, Norman OK: University of Oklahoma, 1989

Sturrock, John *Céline: Journey To the End of the Night*, Cambridge: Cambridge University Press, 1990

Tester, Keith (Ed) *The Flâneur*, London: Routledge, 1994

Trotter, David (Ed) Arthur Machen *The Three Impostors*, London: Everyman's Library, 1995

Vaneigem, Raoul *The Revolution of Everyday Life*, London: Rebel Press, 1994

Wall, Cynthia (Ed) Daniel Defoe *A Journal of the Plague Year*, London: Penguin, 2003

Watkins, Alfred *The Old Straight Track*, London: Abacus, 1970

Woodcock, Peter *This Enchanted Isle: The Neo-Romantic Vision from William Blake to the New Visionaries*, Glastonbury: Gothic Image, 2000

Index

Ackroyd, Peter, 9, 13, 16, 26–27, 32, 34, 40, 45, 53–5, 113, 118–19, 123–27, 138

Against Nature (À Rebours), 20, 67, 78

Apollinaire, Guillaume, 28, 69, 134, 135

Aragon, Louis, 12, 21–22, 72–73, 75–79, 119, 121

Arcades Project, 7, 58, 63, 79

Assault on Culture, 108–9, 132

Atrocity Exhibition, 116

Attempt at a Psychogeographical Description of Les Halles, 99, 110

Baker, Phil, 42, 55, 109, 138

Ballard, JG, 8, 25–26, 103, 112, 114–18, 122, 124–25, 135, 137

banalisation, 13, 34, 84, 102, 111, 116

Baudelaire, Charles, 7, 11, 19–20, 22, 44, 58–61, 63–64, 69, 72, 75, 77, 134

Benjamin, Walter, 7, 11, 19, 22, 58, 60, 63–65, 72, 75, 77, 79

Blake, William, 7, 11–12, 16–17, 29, 31–34, 39–42, 46, 54–55, 65, 69, 112, 119, 126, 138

Blissett, Luther, 131, 143

Breton, André, 12, 21–22, 72–79, 82, 87, 119

Céline, Louis-Ferdinand, 78

Chants de Maldoror, Les, 94

Chtcheglov, Ivan, 83–85, 89

Communist Manifesto, 95

Concrete Island, 116, 118, 137

Confessions of an English Opium-Eater, 32, 42, 55

Crash, 25, 112, 115–16, 118, 137

Critique of Everyday Life, 104

Dada, 13, 27, 73, 82, 88, 132

De Certeau, Michel, 7, 24, 83, 103–4, 106–7, 110

De Maistre, Xavier, 66–69, 78

De Quincey, Thomas, 7, 11–13, 17–18, 32, 42–44, 46, 48, 54–55, 57, 101

Debord, Guy, 7, 9, 10–11, 19, 22–24, 29, 32, 51, 53, 77, 81–83, 85–86, 88–92, 94–103, 108–10, 113–15, 117, 122–23, 130, 132, 137

Dee, John, 130

Defoe, Daniel, 7, 12–13, 15–18, 28–29, 31–32, 35–39, 42, 54, 68–69, 71, 114, 133–34, 137

dérive, 12, 19, 23, 36, 42, 54, 73–74, 78–79, 82, 85, 90, 92–94, 96–99, 102, 108–10

détournement, 23, 82, 92, 94–96, 98, 102, 109, 116

Early British Trackways, 52

Englishness of English Literature, 34, 54, 138

Farr, Roger, 78–79

flâneur, 11–12, 15, 19–20, 22, 28, 44, 49, 57–65, 67, 68–69, 71–73, 77, 96, 103, 113–14, 120, 133–35, 144

Formulary for a New Urbanism, 83

Fortean Times, 121

genius loci, 16, 33–34, 54, 147

Gordon, Elizabeth, 53

Great God Pan, 48

Haussmann, Baron Georges-Eugene, 21, 61, 63

Hawksmoor, Nicholas, 19, 26, 53, 113, 124

Hawksmoor, 26, 53, 119, 124, 138

High-Rise, 112, 116

History of Surrealism, 81
Home, Stewart, 8–9,
 11–12, 27, 32, 45, 85,
 88, 95, 108–9, 113,
 128, 131, 136, 138,
 141
Huysmans, Joris-Karl, 20,
 67–69, 78

Internationale Situationniste,
 54, 92, 96, 99, 108–9
*Introduction to a Critique of
 Urban Geography*, 29, 81,
 88, 109

Jarry, Alfred, 116
Jerusalem, 16–7, 40, 41, 55
Jorn, Asger, 91, 99
Journal of the Plague Year, 15,
 36, 54, 133
Journey Around My Room, 66,
 78

Kafka, Franz, 36, 69–70
Kees, Weldon, 36, 70, 78
Keiller, Patrick, 8, 15, 28,
 33, 36, 39, 69, 71, 114,
 133–9
Kennedy, John F, 116
Khatib, Abdelhafid, 99, 110
Knabb, Ken, 29, 108–10

Laity, Paul, 137
Lautréamont, Comte De,
 94, 109
Lefebvre, Henri, 104
Lettrist Group/
 International, 10, 23–24,
 81, 84–85, 91, 126
Lèvres Nues, Les, 88, 94
ley lines, 18, 26, 33, 51,
 53, 113, 119
Lights Out for the Territory,
 31, 54, 76, 118,
 120–21, 137
London (Blake), 40–41, 55
London (Keiller), 28, 71,
 114, 133, 138
*London Adventure, or the Art
 of Wandering*, 32, 47,
 55
London Orbital, 120, 122
London Psychogeographical
 Association (LPA), 8,
 113, 128, 143
London: the Biography, 123,
 124, 138
Lud Heat, 26, 53, 113, 119,
 121, 124, 137

MacFarlane, Robert, 9, 29,
 97, 109
Machen, Arthur, 7, 13, 17,

18, 26, 32, 45, 47–50, 55, 56, 113, 119, 126

Man of the Crowd, 7, 20, 58, 59, 60, 71, 77, 79

Manifestoes of Surrealism, 72, 79

Marcus, Greil, 110

Marlowe, Christopher, 130

Marx, Karl, 22, 92, 95, 101–3

McDonough, Tom, 109

Methods of Détournement, 94, 109

Michell, John, 52

Mighall, Robert, 47, 55

Mind Invaders, 109, 128–29, 138, 141

Moll Flanders, 37

Monroe, Marilyn, 116

Nadeau, Maurice, 81

Nadja, 21, 73–75, 77–79

Naked City, 91, 109

Nash, Paul, 33

Niederland, William G, 83, 108

Old Straight Track, 18, 32, 51–52, 56

Painter of Modern Life, 58, 77

Palmer, Samuel, 33

Paris Peasant, 21, 72–73, 75, 77–78, 121

Petit, Chris, 71, 78

plagiarism, 27, 94–5, 131, 141

Poe, Edgar Allan, 7, 20, 35, 44, 58–61, 63–64, 69, 71, 77, 79, 87, 134

Potlatch, 22, 85, 86–88, 92, 108

Practice of Everyday Life, 24, 83, 103–4, 110

Prehistoric London: Its Mounds and Circles, 53

Psychogeographical Game of the Week, 22, 86

Revolution of Everyday Life, 23, 83, 102, 104, 135, 139

Rimbaud, Arthur, 15, 20, 28, 59–60, 68–69, 134, 135

Robinson Crusoe, 15, 35–36, 68–69

Robinson in Space, 28, 39, 69, 71, 114, 133–34, 139

robinsonner, 20, 68–69

Rumney, Ralph, 92, 100, 130

Sadler, Simon, 109–10
Self, Will, 9, 111, 122, 137
Sinclair, Iain, 8–9, 11–13, 18, 26, 31–35, 39, 45, 53–55, 71, 76, 111–12, 114, 117–27, 129, 132, 135, 137–38
Situationist International, 7, 10, 22–23, 29, 81, 82, 91–93, 100, 109, 145
Society of the Spectacle, 23, 82, 102, 110, 114, 137
Solnit, Rebecca, 29, 57, 61, 77–79, 83, 108
Stevenson, Robert Louis, 7, 13, 17–18, 26, 32, 45–48, 55, 57, 113
Strange Case of Dr Jekyll & Mr Hyde, 32
Surrealism, 7, 58, 72–73, 77, 79, 81, 121, 132

Theory of the Dérive, 94, 96, 99, 108–10

Things Near and Far, 49, 56
Three Impostors, 48, 55
Tour Through the Whole Island of Great Britain, 38, 133
Trocchi, Alexander, 101
Trotter, David, 55

unitary urbanism, 54, 94

Vague, Tom, 129
Vaneigem, Raoul, 23, 83, 100, 102–4, 132, 135, 139
View Over Atlantis, 52

Wall, Cynthia, 37, 54
Wanderlust: A History of Walking, 29, 57, 77–78
Watkins, Alfred, 7, 18, 26, 32, 51–54, 56, 113, 119
Wilde, Oscar, 45, 67
Wolman, Gil J, 94, 109
Woodcock, Peter, 33–34, 54, 147
Wordsworth, William, 43

UTOPIA

Merlin Coverley

For more than 2,000 years utopian visionaries have sought to create a blueprint of the ideal society. From Plato to HG Wells, from Cloud-Cuckoo-Land to Shangri-La, the utopian impulse has generated a vast body of work, encompassing philosophy and political theory, classical literature and science fiction. And yet these utopian dreams have often turned to nightmare, as utopia gives way to its dark reflection, dystopia.

The Pocket Essential *Utopia* takes the reader on a journey through these imaginary worlds, charting the progress of utopian ideas from their origins within the classical world, to the rebirth of utopian ideas in the Middle Ages. Later we see the emergence of socialist and feminist ideas; while the twentieth century was to be dominated by expressions of totalitarian oppression. From the novel to the political manifesto, from satire to science fiction, utopias have always reflected the age that gave rise to them. This guide will explore this historical context, offering both an analysis of the key texts and an account of their political and cultural background.

Today, it is claimed that we are witnessing the death of utopia, as increasingly the ideals that give rise to them are undermined or dismissed. These arguments are explored and evaluated here, and contemporary examples of utopian thought are used to demonstrate the enduring relevance of the utopian tradition.

A SHORT HISTORY OF EUROPE

Gordon Kerr

What is Europe? Firstly, of course, it is a continent made up of countless disparate peoples, races and nations, and governed by different ideas, philosophies, religions and attitudes. Nonetheless, it has a common thread of history running through it, stitching the lands and peoples of its past and present together into one fabric. This narrative is welded together by the continent's great institutions, such as the Church of Rome, the Holy Roman Empire, the European Union, individual monarchies, trade organisations and social movements. At times they have prevented anarchy from destroying the achievements of the many great men and women the continent has produced. At other times, of course, it is these very institutions that have been at the heart of the war and strife that have threatened to reduce Europe to ruin on numerous occasions.

Europe, however, is also an idea. From almost the beginning of time, men have harboured aspirations to make this vast territory one. The Romans came close and a few centuries later, the foundations for a great European state were laid with the creation of the Holy Roman Empire – an empire different to any other in that it enjoyed the approval of God, through the Church in Rome. Napoleon overreached himself in attempting to create a European-wide Empire – as did Adolf Hitler. Now, however, Europe is as close as it ever has been to being one entity. The European Union is an ever-expanding club of which everyone in Europe wants to be a member, although, as the recent rejection of the European Constitution by the French and the Dutch, demonstrates, we Europeans still cling to our national independence.

THE KNIGHTS TEMPLAR

Sean Martin

The Knights Templar were the most powerful military religious order of the Middle Ages. Formed to protect pilgrims in the Holy Land, they participated in the Crusades and rapidly gained wealth, lands and influence and were answerable to none save the Pope himself.

In addition to having a fearful military reputation, they were also Christendom's first bankers — inventing much of the modern banking system that is still in use today — and were also involved in exploration and engineering.

Seemingly untouchable for nearly two centuries, the Templars fell from grace spectacularly after the loss of the Holy Land: in 1307, all Templars in France were arrested on charges of heresy, homosexuality, denial of the cross and devil worship. The order was suppressed by the Pope in 1312, and Jacques de Molay, the last Grand Master, was burnt at the stake as a heretic two years later.

The myth of the Templars was born and in the ensuing seven centuries, they have exerted a unique influence over European history: orthodox historians see them as nothing more than soldier-monks whose arrogance was their ultimate undoing, while others see them as occultists of the first order, the founders of Freemasonry, possessors of the Holy Grail and the Turin Shroud.

'A well written and easily enjoyed introduction to the history of this extraordinary crusading Order of military monks whose account still manages to fascinate even after all this time.' Michael Baigent, *Freemasonry Today*

'Do not be deceived by the book's seeming brevity. For this book contains more information than many recent books on the Templars weighing in at three to four times this one.' Stephen Dafoe, *Templar History*

To order your copy
£7.99 including free postage and packing
(UK and Republic of Ireland only)
£9.99 for overseas orders

For credit card orders phone 0207 430 1021 (ref PSY)

For orders by post — cheques payable to Oldcastle Books,
21 Great Ormond Street, London, WC1N 3JB
www.noexit.co.uk